CONVERSATIONS WITH THE BRUSH

WISDOM TALES FROM THE INTUITIVE PAINTING
HEART

CHRIS ZYDEL

Creative Juices Arts Press

Publishing Coordinator: Naomi Rose

www.naomirose.net

Proofreader: Gabriel Steinfeld

gstein@sonic.net

Cover, Illustrations, and Typesetting: Timothy Lajoie

First edition. Published 2021.

Printed in the United States of America.

ISBN #: 978-1-7363284-0-8 (Paperback Edition)

ISBN #: 978-1-7363284-1-5 (eBook Edition)

To Tim, my Sacred Temple Builder…

who makes all my dreams come true.

— "Your heart knows the way. Run in that direction." ~ Rumi

CONTENTS

PART I

INTRODUCTION

1

A LOVE NOTE TO YOU

There are three things you need to know about me before you get into this book. The first is that I wanted to paint when I was a kid. Badly. For a million different reasons it never got to happen, which kind of broke my tiny artist's heart.

The second is that I'm fiercely independent. I can't stand having someone tell me what to do. Ever. Especially around my art.

The third is that when I was seven years old, I used to walk to school hand in hand with an invisible—to everyone but me— angel friend. That sacred presence is still a big part of my life.

These three things are the big "why" behind this little book.

I know lots of folks had their hearts broken as kids, and even as grownups, through judgment, criticism or neglect, when all they wanted to do was to express themselves freely through their art. Here's something that I want everyone reading this book to understand: it's possible to heal those wounded places with awareness and love. I'm hoping that this book will help those tiny broken artist's-hearts to become whole again. Truly satisfying artistic expression only happens when it is authentic

CHRIS ZYDEL

and real and that kind of originality can't happen when you're given the message that you need to create like someone else.

My wish is that reading these stories will be like a creative permission slip for your soul to express yourself any damn way you please and to stop worrying about other people's opinions... including your own... about you or your art. I want you to feel deeply encouraged to remember that you are creatively—and in all ways—more than good enough just as you are. I hope that in these pages you will find the courage to step through that sacred portal into making art as an ancient and powerful way to talk to Spirit, to develop a deep trust in your creative muse (otherwise known as your intuition) and to connect with the vastness of your most essential self through the simple, down-to-earth act of putting paint on paper or canvas. I want you to remember that you are magic, to connect with the truth of your creative genius and be inspired to embrace a greater sense of artistic liberation and wild creative freedom in your painting process.

I send you much love and offer you my deep faith, based in vast experience, that if you take some of these principles and practices and make them your own you are guaranteed to experience powerful creative transformations in both your art and your life. Including healing your artists broken heart.

WHAT IS INTUITIVE PAINTING?

The stories in this book come out of interactions with my students using the Wild Heart Expressive Arts intuitive painting approach. So I thought it might be helpful to give you some idea as to what it means to paint from your intuition.

Intuitive painting, also known as process painting, free-expression painting, soul painting, or do-whatever-the-heck-you-feel-like painting, is radically different in approach and intention than more traditional types of art classes. The philosophy behind intuitive painting is that *everyone* is creative. You don't need any special skills or talent in order to make art.

When you paint from your intuition, what matters the most is you becoming more creatively alive. What is valued and supported in the intuitive painting process is your inner experience as you paint, not what your painting looks like at the end.

Most of us learn that art is only valuable if the final product is pleasing to both the painter and people viewing the painting. We judge our paintings as successful if we like how they turned

out. We believe we achieve creative success through mastering certain techniques and skills. We do all this so that we can feel good about our art and ourselves as creators.

This is what I want you to consider: if your primary goal when making art is to achieve a particular end result, you will inevitably approach your painting process from your head. You will find yourself constantly thinking, planning, and assessing, making sure that your painting meets some kind of external criteria of being "real" art. In order to feel like your creative process is worthwhile, it has to conform to often oppressive and unrealizable cultural expectations that you as the artist have internalized. This means your unique artistic expression is always being shackled in one way or another by inner or outer judgments that include perfectionism, comparison, and the need for external approval. But the price you pay for adhering to all those rules and conventions is that you as the creator can never be truly free.

Intuitive painting, however, is an art-liberation practice where the intention is to emancipate your creative self. When you paint from your intuition, you are challenged to surrender your need to control the outcome and to develop total trust in your own creative process. You are asked to pay attention to how your intuition expresses itself through your body, your heart, your impulses, and your emotions. You are encouraged to notice how you *feel* as you paint instead of what you think about your art.

Your opinions about what's good or bad, right or wrong, successful or a colossal failure don't matter when you make art from your intuition. And neither do anyone else's.

Intuitive painting is a powerful spiritual and creative practice that is designed to transform your relationship to your intuition. It teaches you how to tell the difference between your intuitive

intelligence and your analytical/judging mind. Then it helps you to develop a solid allegiance to, and trust in, your intuitive self.

When you paint from your intuition, your paintings don't always make sense.

They don't unfold in a linear, logical, rational way, but follow their own mysterious flow. Painting from your intuition means you are entering the dream time and allowing your imagination to run wild. You gain confidence in your spontaneous impulses and develop a greater capacity to be comfortable with uncertainty and the unknown.

Painting from your intuition supports you in claiming the courage to explore and experiment, to break the rules, to become a creative revolutionary, to make things up and take outrageous creative risks. You become a bold adventurer on the quest to awaken to your inner truth. You bravely enter into the shadow realms of your psyche, allowing the practice of painting to transform your ancient stories and beliefs of being creatively inadequate into a sense of being grounded in your own wild and untamed creative genius.

When you are making art by allowing your intuition to lead the way, you discover the only questions that really matter: "Am I deeply engaged with what I'm creating?" "Where do I feel the most energy and creative juiciness as I create?" "What allows me to be the most fully alive as I put this brush on the canvas?" "What does it mean to fully express myself?" "If I didn't have to worry about what my painting looked like to anyone else, what could I allow myself to see and express?"

The simple act of being creative, without a goal or a plan, is incredibly satisfying. The process itself is healing and more than enough. Releasing yourself from the expectation that your only

value lies in how you perform, and in what you produce, opens up worlds of possibility. It reignites your natural joy in creating. You find that you can let go, have fun, and rediscover the power of play.

All creativity is sacred, and opening up to the experience of loving your art without judgment leads to the profound experience of loving yourself just as you are.

Think of intuitive painting as meditating with a brush in your hand. As you release your attachment to judgment, planning, and some future goal, the practice allows you to open to a greater sense of presence, spaciousness, and self-compassion. It's an invitation to wander into the dreamtime, the mystery, and the invisible, multi-dimensional realms.

Intuitive painting is also a commitment to deep soul work, to making what is unconscious conscious, to finding your personal medicine, and to becoming awake, alive, and whole. It's a sacred summons to become more real and authentic and more of who you were always meant to be. It's a process of developing an unshakeable alliance with both your inner wise self and your inner healer.

Making the choice to enter into intimate communion with the inner world of your heart, mind, and spirit, and holding space for *you* means welcoming everything you find in that vast terrain, without judgment or preference.

Deep grief, profound joy, intense pleasure, holy rage, radiant brilliance, wild freedom, and mega-watt power are all present inside of you. Holding all of who you are in an attitude of radical self-acceptance metamorphoses you and allows you to stretch outside of what is easy, comfortable, and familiar.

There's one more thing I want you to know: intuitive painting is an ongoing practice of devoting yourself to trusting in the life force and ultimately in life itself. So many things about being alive are painful, difficult, or scary. There are times that things simply don't turn out the way you want them to.

Disappointments and frustrations abound on a regular basis. Life is a constant flow of change, and change always involves the experience of loss. Often, when confronted with those kinds of challenges, our first impulse is to try to change or fix or resist them. Intuitive painting teaches you that there is a holy wisdom in allowing yourself to be led and guided by whatever shows up on the page in front of you. It urges you to let go of the need for certainty, and guarantees to open you fully to what you can never know with only your mind, but can feel so very deeply in your heart.

Intuitive painting awakens in us a trust in the wisdom of our personal unfolding, the experience of inner guidance, and the grace of divine timing. It reminds us over and over again that willingly going towards and surrendering to what we normally try to avoid and control will allow us to become even more fully and achingly alive.

3

HOW TO USE THIS BOOK

At the end of one of my workshops or retreats, people will invariably say something along the lines of, "Oh my goodness. This is one of the most amazing things I have ever experienced. But now I'm going home and people are sure to ask me what I did here and I have *no idea* what to tell them!"

The intuitive painting process is unlike most art classes, because you're not here to learn a technique. You're not even here to make a visually pleasing painting. So it's not like you can bring something back with you that other people can easily understand.

The purpose behind this approach to painting is to get out of your head and, instead of *thinking* about what you're creating, to open the door into your direct experience of *being* with the creative process on a very visceral and energetic level. The invitation is to move away from language, where we are continually describing our experiences to ourselves, into the wordless zone of intuition, feeling, and creative action. That makes it kind of hard to talk about to the folks back home.

I have struggled, over my many years of teaching this process, with finding ways to articulate the beauty and power of what happens in the studio. I've been all over the map in terms of my success; but then I stumbled upon the most ancient way of communicating *anything,* which is through telling a story. Stories get us out of our heads and into direct experience. They transport us through our imagination into another world. They are another way of bypassing the left brain, opening the door into the world of moods and emotions. Stories are also the best teaching tools around, because they are not abstract. They are very grounded in the reality of a given situation. They encourage us to identify with the characters in the stories that are being told, allowing us to feel what they are feeling and to empathize with their struggles.

Stories also entertain us. They keep us engaged: laughing, crying, and sometimes squirming in recognition, while unconsciously learning from the characters foibles, mistakes, and glorious ah-ha moments. Before we know it, we are absorbing some concept or idea without even trying.

I created this book with the intention of helping you get inside the experience of the intuitive painting process, and to witness through these stories the challenges, stuck places, confusion, and frustration that shows up when we get caught in linear or judgmental mind-loops. My hope is that you will see your own creative struggles in these stories and discover what it looks like to happily break free of those mental shackles.

Each chapter is a different story, and each story references a particular intuitive painting principle or practice, with a bit of an explanation about the concept being addressed at the end, along with some journal questions and painting prompts to help make the intuitive painting process come more alive for you.

The stories in this book are not presented in any particular order. You can read them straight through from the beginning or randomly allow various tales to speak to you.

These stories are fun to read; at least that's what I've been told! Hopefully they will bring you a sense of inspiration and hope around your creative process, but you can use them purely for their entertainment value alone. They are also meant to help release you from the way *your* mind is tying you up in knots around your creative self-expression. One thing I would recommend is to read a story and then see how you can apply what you've learned to your own creative practice.

Most of these stories were inspired by actual conversations with real students in my classes, workshops, and retreats. Some of them are verbatim, but most are composites of conversations— with a heavy dose of poetic license—that I have had many, many times with many, many students over my twenty-five years as an intuitive painting teacher and facilitator. I hope you enjoy reading them as much as I have enjoyed writing them.

PART II

STORIES

4

ZEN FISH

Me: So, how's your painting going?

Student: Well, to be perfectly honest it's kind of freaking me out.

Me: Why is that?

Student: Well, I painted this bigmouthed purple fish, with yellow whiskers.

Me: Uh-huh.

Student: And then I accidentally messed up the fish.

Me: Yeah?

Student: And when I went to fix the fish it yelled at me!

Me: What did it say?

Student: It said, *"Don't fix me!"*

Me: OK. So, did you fix it?

Student: Of course I didn't fix it! I was too startled to do anything, and what do you mean by "OK"? I know you said that

our paintings could eventually talk to us, but I didn't think you meant like *actually* talk.

Me: What did you think I meant?

Student: I don't know. I thought it was a metaphor or something, but it actually talked, like, out-loud talked!

Me: Did it say anything else?

Student: Yes, it did. It said, "And you don't need to fix anything *ever*." That's what really freaked me out.

Me: Why was that?

Student: Well, here's this big-mouthed purple fish, with yellow whiskers, talking to me like a freaking Zen master!

Me: And that's a problem why?

Student: It just seems wrong somehow, and it's completely scrambled my brain.

I don't know *what* to think now.

Me: Well, maybe that's the point. Any Zen master will tell you that thinking is *highly* overrated.

Student: Yeah well, I've definitely heard that before, but now I don't think I'm ever going to forget it. Every time I try to fix something from now on I'm going to see and *hear* that darned purple fish yelling at me.

Me: Then I would say that your painting's work is done, at least for now.

Student: You mean this could happen *again*?

Me: I think you can pretty much count on it.

There are only a few basic practices that are the backbone of the intuitive painting process. Each one of them is designed to give you more creative freedom and to challenge your allegiance to your left brain and analytical mind, which is the part of you that regularly puts the brakes on your spontaneous creative flow.

None of these practices are easy to adhere to because they require you to let go of deeply entrenched patterns of control. And you profoundly believe that these old familiar patterns will keep you safe. But following these practices is guaranteed to make you feel uncomfortable because you're being asked to let go of control which means bucking your inner status quo in a big way.

None of them is more challenging than the practice of trusting your spontaneous creative expression without editing it after the fact. Simply being with whatever shows up on your paper or canvas from a place of curiosity makes that part of us that wants to maintain order at all costs extremely anxious.

The desire and the *compulsion* to go back and fix, improve upon, or try to make something better that has already been creatively expressed is never a true creative act. Creativity is always about moving forward toward what's next. It's a call to what's new, to what wants to be revealed, and is ready to be born. Fixing keeps us *fixated* on the past, on what we think is wrong and on our belief that there is such a thing as not good enough.

Fixing is a fantasy that ultimately keeps us stuck and small. Since you really can't fix anything to the satisfaction of your endlessly grasping for perfection ego mind, your trying to do so

will only lead to continued frustration. Fixing is a way to avoid the anxiety of your authentic creative unfolding, the spontaneously unbridled call to creative action and the risk of making art...or a life ...that you can't control or don't always understand.

That is why a commitment to not fixing is such a wildly creative and ultimately spiritual choice. If you want flow instead of flummoxed, freedom instead of fettered, release instead of restraint, then you will let go of your attachment to how you think something should have turned out, and keep going towards what it wants to become if only you can get out of its way.

1. Write about a time when you felt compelled to fix or change something that appeared spontaneously in one of your paintings.
2. What was it that made you so uncomfortable that you had to change it?
3. What do you think would happen if you resisted the impulse to fix or change the thing that was bugging you?
4. Next time you paint pay attention to when this compulsion to fix things arises and take a moment to explore it instead of immediately acting on it.

5

ANGEL WINGS

Me: How's your painting going?

Student: Pretty good! I think it might be done!

Me: Great! Let's just go through the little drill I take everyone through at the end of the painting process to see if there's anything else that could possibly happen.

Student: OK.

Me: So is there anything you thought of that you didn't do on this painting?

Anything you censored or said "no" to?

Student: (Silence)

Me: You OK?

Student: Yeah, I'm OK, but why did we have to start with that question?

Me: I always start with that question. Is there a problem?

Student: Well, there *is* something that occurred to me to paint, but I really don't think it's a very good idea.

Me: Why don't you tell me what it is?

Student: Well, I *did* think about putting more developed wings on the figure in the center here.

Me: So why didn't you do it?

Student: I don't think it really *needs* the wings to be spelled out. There's kind of a hint of them with those pink swirls behind the figure, and that's probably fine.

Me: But it sounds like you thought about adding more to those pink swirls. What exactly did you see?

Student: Oh no. I know where this is going to lead. I'm not going to tell you anything more about what I'm seeing.

Me: (Looking at my watch)

Student: What are you doing?

Me: Oh, I'm just timing you to see how long it takes you to tell me what it is you're convinced you're not going to tell me.

Student: (Grumbles for a bit longer) All right, all right. I am seeing these big angel wings full of white fluffy feathers that are taking up half the page. Are you happy now?

Me: Twenty-five seconds. I think that's some kind of a record for you. You really held out this time!

Student: *Arrrrrgh*! I can't paint angel wings. First of all they are so *trite*. Plus, I don't know *how* to paint feathers. If I try it, I know I'm going to screw up the whole painting.

Me: It sounds like you have a lot of stories about what's going to happen if you paint these wings.

Student: You know, you have this reputation for being so incredibly nurturing and empathetic, but I don't think you've listened to a word I've said.

Me: Well, actually you're right. I'm *not* listening to most of your words. You're doing pretty well with that on your own. I'm paying attention to your body language and your energy, and they are telling me a whole different story.

Student: What on earth are you talking about now?

Me: Well, I've been noticing that every time you say "angel wings" or "feathers," your chest opens, your shoulders go back, your chin goes up, your voice raises a couple of decibels and you get this wild twinkle in your eyes.

Student: *So?*

Me: So, what that's telling me is that you're actually very excited about the prospect of painting those wings. The stories you are telling yourself about why you can't paint them are just trying to get in the way of your true creative desires.

Student: How can you say that? Don't you think that if I really wanted to paint those wings I would know it?

Me: Uh... no. Obviously you really *do* want to paint those wings and yet you don't know it.

Student: How can I not know what it is that I really want?

Me: Now we're talking. That's an excellent question!

Student: Why do I get the feeling all of a sudden that I'm royally screwed?

Me: I think that you're just fine. It's your old limiting stories about what you believe you can and can't do that are royally screwed. But hey, if you want to continue holding on to those beliefs, be my guest. I'm not going anywhere. I've got all the time in the world.

Student: That's exactly what I'm afraid of, and do you really need to be so *cheerfully* relentless?

Our intuition is continually inviting us to expand and grow, and that means encouraging us to try things that we think we can't do because we've never done them before. It doesn't believe us at all when we protest that we are inadequate to *any* task. It knows that we are way more capable than we give ourselves credit for, and that our essence always wants us to bloom and blossom, even when our personality feels collapsed and afraid.

However, if we are really honest with ourselves, we need to admit that our personality is *often* collapsed and afraid, and that the fearful part of us is running the show and on automatic pilot most of the time. That's what waking up is all about. It's recognizing that our judging mind is a slippery trickster and has one job and one job only, which is to keep us from knowing who we *really* are, and also recognizing that this part of our mind is *very* good at this job.

So, in order to be more fully creatively vital and alive, you need to be operating from the premise that you are most likely pushing some part of you into the shadows, even if you don't think you are. Just *assume* that your judging mind is holding you back in one way or another. If you start from that premise, you

are much more likely to ferret out the juicy stuff that's hiding in the corners than if you've got yourself convinced that you are totally open and free.

The likelihood that we *are* totally open and free is actually pretty slim. Believing that is the case is one of the ways that we snooker ourselves. Learn to practice the humility of knowing that there is a part of you that is highly invested in keeping you asleep, and that the only way to truly wake up is to concede that it is probably successfully keeping you asleep *right now*. Stay curious about the high probability that your ego is lying through its teeth. If we don't consider the possibility that there's anything else to discover, we're never going to find it.

1. Make a list of the types of images that you habitually avoid when you paint because you're convinced they will turn out badly.
2. Are there colors that you don't use (like black or glitter or fluorescents) because you have some judgment around them?
3. What are those judgments?
4. Next time you paint are you willing to experiment with some of those images and colors even though they make you uncomfortable?
5. What happens when you do?

GLITTER FISH

Me: How's your painting going?

Student: Well, I'm feeling kind of stuck.

Me: OK. What do you mean by stuck?

Student: Well, you know that I love painting fish.

Me: Yeah.

Student: So, I want to paint a fish.

Me: OK.

Student: But I keep going back and forth in my mind, saying things like, "I want to paint a fish." "But you ALWAYS paint a fish." "Why can't I paint things other than fish? Maybe it's weird that I like painting fish. I probably shouldn't paint a fish." "But if I don't paint a fish, I don't know what else I would paint. So, maybe I should paint a fish."

Me: Whoa! I get dizzy just listening to you.

Student: I know, and then while I'm going around in circles I don't do anything at all. I just stand here looking at the painting, trying not to think about fish.

Me: The thing that strikes me about your monologue is that it's just so darn familiar. Everyone in this room has had similar conversations with themselves. Just substitute "fish" for something like "tree" or "hearts" or "glitter."

Student: You mean people try to talk themselves out of *glitter*?

Me: I know. Shocking, isn't it? But the inner critic has no shame, and it's also not very creative.

Student: So, what should I do?

Me: You're kidding me, right?

Student: OK, OK. I guess I'll paint a fish, and add some glitter while I'm at it!

Me: All right! That's showing Mr. Judgy who's boss around here!

Our creative intuition shows up in a multitude of ways, but it also has certain preferred channels for how it likes to express itself. That can look like repeating images or themes that show up over and over again.

I call these types of images or colors our *personal iconography*, and they appear so frequently because they carry tremendous meaning for us. They express something very deep and fundamental about who we are, even if we don't always know what that is.

The judging mind tries to make us believe that following the energy these personal images bring when we express them through our brush means we are not being creative. It accuses us of being boring or uninspired. It tries to convince us that we're just being creatively lazy and unoriginal, but nothing is further from the truth.

Making the space for these repeating images deepens your connection with what is true and essential in your creative soul. They actually allow you to be *more* creative because you are trusting in what has the most heart and meaning for you, and then expressing it. That ongoing trust in your soul's often mysterious desires is what opens your creative channels wide and is best responded to with a big, no-holds-barred, joyful *yes*!

1. What are certain images and colors that you find yourself drawn to over and over again?
2. How do you feel when you paint those images and colors?
3. If you have a judgment about those images and colors what is that inner critical voice saying to you?
4. Practice painting those images and colors to your hearts content without censoring or stopping yourself and see what happens.

7

ANTI-FUN

Me: How's your painting going tonight?

Student: I'm painting these black and purple squiggles over here and I'm feeling kind of disconnected.

Me: What do you mean by disconnected?

Student: Well, painting this is feeling tedious, like it's just a lot of work.

Me: So, what was the last thing you painted that *didn't* feel tedious?

Student: I was really having fun when I was finger-painting with those same colors at the top of the paper.

Me: So, why did you stop doing that?

Student: I don't know. It just seemed like I should move onto something else.

Me: According to who?

Student: Some voice in my head thought I had had enough.

Me: Enough of what? Fun? Pleasure? Purple fingers?

Student: Oh my God! I am so totally busted! I can't believe I just did that. Why is it so hard to let myself have fun?

Me: I think a better question might be, why do you even listen to that darn anti-fun voice?

Student: I don't know, but I think I'm going to stop doing that now.

Me: I think someone here is going to be very happy, and, lucky for you, it's not going to be that voice.

When folks start down the path of creative self-awareness and opening up to their creative energy, they worry that stuff will come up for them that's emotionally painful or difficult. And that *is* often a part of the creative process, but the thing that is even more difficult for just about everyone is learning to tolerate joy. It's like we have an invisible happiness ceiling, a secret limit to how good we can allow ourselves to feel. I can't tell you how many times people in my workshops will begin to experience the intense pleasure that happens when they open to creative source and will say things to me like, "Are you sure it's OK for me to be having so much fun? It almost feels like it shouldn't be legal to feel this wonderful." Then they unconsciously start to shut down the blissful feelings, allowing themselves to be distracted by the sneaky voice of "should" or "have to" or "supposed to." This means they never get to see what's on the other side of their joy frontier.

It's scary to cross that line. It brings us up against all those places inside where we think we don't deserve delight. Bliss changes our perception of ourselves. If our identity is based on a sense of lack, deprivation, and low-grade misery, then feeling filled with more pleasure than we know what to do with really messes with our sense of who we think we are.

The next time you come up to your creative happiness edge, ask yourself these questions: Can you let yourself be a creative fool for gladness? How much joy can you stand?

1.) What comes up for you when you hear about this concept of a happiness or joy ceiling?

2.) When have you experienced stopping your creative process because the pleasure or energy became too uncomfortable?

3.) Notice when you hit that edge of joy in your painting process and see if you can hang out there a bit longer than you normally would. Write about what comes up when you do that.

UNCOMPLICATED BALD GUY

Me: So how's your painting going?

Student: Well, I decided that I wanted to paint this guy with a bald head.

Me: Yes?

Student: And so I painted him.

Me: So, how did it feel?

Student: It felt great, but I don't understand why I wanted to paint him.

Me: So, you're feeling confused.

Student: Well, not exactly. I mean it's OK with me that I don't know why I painted him.

Me: So, what's the problem?

Student: It all seems too easy.

Me: What do you mean?

Student: Well, I decide to paint this guy for no reason.

Me: Yes?

Student: And so I paint him.

Me: Yes?

Student: And I enjoy it.

Me: Uh-huh?

Student: Well, it just seems too simple somehow. Shouldn't this be a lot more complicated?

Me: Why do you think that?

Student: Well, because *life* is a lot more complicated, and you're always saying that painting is like your life. I mean, you can't just decide to do something in your life for no good reason, and then just go ahead and *actually* do it simply because you want to!

Me: (Laughing so hard that I can't talk)

Student: Can you?

One of the biggest lies we have ever been forced to swallow is the belief that we have to know *why* we're doing something before we actually do it, and that things have to make sense before we can act upon them. This is one of the many ways that we keep ourselves paralyzed and unable to move forward when we are blessed with a hunch or an intuition about a step we could take.

Our intuition/creator is not always interested in what makes sense to the judging/critical mind. It has an intelligence that goes beyond what we can understand in any kind of linear way. It signals us with good feelings like excitement, curiosity, and joyful anticipation.

If it's simple, easy, and uncomplicated, we're on the right track. The mind is totally fascinated by problems that can't ever be solved. So it is constantly creating those problems. Our minds thrive on making things difficult, but our hearts are interested in fulfillment and satisfaction, on what is effortless, fluid, and flowing. Our hearts want us to open to the possibility of grace.

The heart is what we are being invited to trust through this intuitive painting process. So, the question you need to ask yourself is this: Can I take this next step in my creative process, even though I have no idea where it's leading me? Can I allow things to be simple and uncomplicated? Can I trust that my intuition is plugged into something bigger than my rational mind?

1. What is your relationship to ease and flow?
2. How do you tend to overcomplicate things in your art and your life?
3. What messages did you get from your family or culture about the importance of "thinking things through"?
4. How often do you allow yourself to follow your impulses and do something without a good reason to take that action?
5. What happened when you did that?

CRASH HELMET

Me: So how's your painting going?

Student: I don't know. I'm feeling really super-agitated.

Me: And there's a problem with that?

Student: Well, yeah. I don't like feeling agitated. It's disturbing. I would much rather be in the flow.

Me: You know, agitation is just another form of energy that you can use to create from if you don't judge it or try to change it, and you are in the flow. It's just a class-five rapids kind of flow.

Student: *Arrrrgh!* I need a crash helmet!

Me: All you really need is a paintbrush.

Another myth around the creative process is that we have to be in a certain state of mind in order to create. We all have different

versions of what that is. For some folks, it is the high of inspiration. For others, the belief that they have to be calm and serene. But this idea is incredibly limiting to our creative process. If you are waiting around for the perfect state of being, you are in danger of never, ever creating. Demanding that you feel a particular, preferred way before you're willing to make art is just another way of being in control, and control is the creativity killer.

The truth of it is, you can create no matter what you're feeling. You can create when you're sad, angry, sleepy, frustrated, cranky, irritable, confused, unclear, or totally convinced that you're blocked. Your creative genius is smart enough to take anything you're experiencing and turn it into art. You just have to get out of the way and let it happen, and allow yourself to be surprised by whatever shows up.

1. What are your beliefs about how you need to feel in order to be creative?
2. How do those beliefs support or hinder your creative process?
3. Take a few minutes to paint each day no matter what or how you feel. Notice what happens when you make art from different states of being.

CREATIVE WEIRDSVILLE

Me: How's your painting going tonight?

Student: On my way to class, I was thinking about this painting and I just *knew* that I really didn't want to paint anything underneath that head that is already there.

Me: What is this thing that you don't want to paint?

Student: I don't know. I just know I really *don't* want to paint it.

Me: Well, what *could* you paint there?

Student: Well, I could paint a body with some arms attached. Yeah, that would be OK.

Me: But it's not the thing you really don't want to paint, is it?

Student: No, it's not. How did you know that?

Me: I've got mad psychic skillz. Plus, you sounded incredibly bored when you talked about painting the body. So, what is that thing you really don't want to paint?

Student: You're going to make me say it, aren't you? Well, I *really* don't want to paint an explosion around that head.

Me: Hmmm. How badly do you not want to paint that explosion, and while we're at it, what color is this explosion that you really don't want to paint?

Student: *Arrrrgh!* Oh dear, but that explosion is something that I don't want to paint in the *worst* way, and it's very clearly red, black, and orange.

Me: Well, you know how it works here. A big *no* is just as good as a resounding yes. The only thing that matters is if you've got juice for something.

Student: What do you mean "a no is as good as a yes"? That's crazy talk!

Me: I've certainly heard that before.

Student: We're not in Kansas anymore are we?

Me: Nope, we took a left turn into Creative Weirdsville quite a ways back.

Following the energy can sometimes mean doing what the judging mind doesn't want us to do because it's scared or doesn't have a clear sense where this particular creative impulse is going to ultimately lead us. The more intense the secret desire to *do* the scary thing, the more resistance rises from the mind. It's like it mounts a counterattack in direct proportion to the size of the energy that wants to come through. But energy is simply energy. If we have a powerful charge around a particular image or color,

it's something that wants and needs to be expressed, even if it's something we think we don't want, or even like. We can't ever trust our thoughts, or opinions to guide us through these places where energy and feeling are running the show.

Sometimes the things we most want to avoid are exactly the things that we need to embrace. The soul talks to you in the language of fervor and voltage, intensity and vibrancy. It doesn't really care if what it wants you to do pleases you or anyone else. It doesn't care if following its directives is going to make you uncomfortable. It doesn't really give a hoot about pushing you into situations that you don't think you are ready for, or are equipped to do. It's only concern is whether or not you are following the sacred breadcrumbs of aliveness. That's why the only question you *ever* need to ask yourself when you're painting is this: "Am I following the energy right now?" Or "Where's the juice?"

1. How do you respond to prompts from your intuition that make you uncomfortable?
2. What is your definition of energy?
3. How do you feel and experience energy when you're making art?
4. Are you willing to follow your creative energy wherever it may lead you? Why or why not?
5. Where is your energy right now?
6. Paint from that place.

DISCOMBOBULATION

Me: So how's it going with your painting?

Student: *Arrrrgh!* I don't know. I'm frustrated. I don't understand this painting *at all*.

Me: Uh-huh.

Student: I mean, for example, look at this. Here's a duck inside a tree sitting on top of a one-eyed monster's head. What the hell is *that* supposed to mean?

Me: Why does it have to mean anything?

Student: Well, if I don't understand it, why should I even paint it?

Me: Do you have energy for what you're painting?

Student: Yes, yes! There's tons of energy, and I don't understand that either. It's just weird, and weird makes me nervous. How is it that I can be so engaged in painting something that is so absurdly meaningless? What is my intuition trying to do to me?

Me: What do you think?

Student: I think it's trying to drive me bonkers.

Me: Well, it sounds like it's doing a very good job of driving bonkers the part of you that wants things to make sense.

Student: But isn't that the part that really matters?

Me: Ahhhh. That's quite an interesting assumption. Maybe your intuition wants you to experience things *not* making sense for awhile.

Student: *What*? Why would it want me to paint meaningless paintings?

Me: Maybe because you're too attached to things being meaningful!

Student: But I *want* things to be meaningful. It makes me very happy when I can figure out *why* something is happening.

Me: But apparently your intuition doesn't think that's such a good idea right now, otherwise your painting wouldn't be so darn incomprehensible!

Student: (???) I feel like my brains are being scrambled right now.

Me: Good, good! I think we're getting somewhere.

Student: This has got to be one of the most ridiculous conversations I have ever had.

Me: Yes, yes! You're right, it *is*!

Student: Why is that a good thing?

Me: Well, if you feel like you always have to interpret what's going on in a logical way, it leaves very little room for the mystery and the unknown to take over. So, your intuition will

bring in a good dose of holy confusion to rattle your left brain's cage, leading you into a state of total bewilderment and discombobulation to lessen the grip of your rational mind on the creative process. Like now.

Student: My head hurts.

Me: Do you still have energy for the painting?

Student: (Grumbling) Yes, yes, yes. I *do* have energy for the painting. Even *with* this headache.

Me: So you're proving to yourself that you can happily paint a totally meaningless painting without having *any idea at all* about what's going on, or why. I'd say you made some real progress tonight!

Student: How can going around in circles in a muddle of aimless futility be progress?

Me: That's what you're going to find out!

We often make the mistake of believing that the process of meaning making only happens in our minds. If we can't describe what's happening internally on a cognitive level using language, we have a hard time valuing the non-verbal aspects of our inner life, or even acknowledging that they exist. But we continually experience meaning on the level of feelings and emotions that have no words. We can sense meaning in our bodies and our bones that can't be talked about in any kind of rational way. We *know* it's there on some very deep level. We just need to be reminded to notice and embrace it. And to open

ourselves to the idea that felt meaning without intellectual comprehension is just as important as understanding something through our left brain thinking function. When we only pay attention to the meanings we can articulate and analyze, it keeps us in our heads. But this process of intuitive painting is designed to include access to the powerful wisdom that lives in our bodies and emotions. And to allow that wisdom to be appreciated, cherished and respected.

1. Next time you paint begin to notice your inner running commentary. What are the stories you're telling yourself about your painting? Do you find yourself analyzing what each aspect of your painting means?
2. Try an experiment where instead of thinking about your painting using language, bring the focus of your attention to your body and your emotions and simply feel what's there with no narrative.
3. What do you notice about your painting process and your experience of painting when you make that shift?

EMPTY-HEADED PAINTING

Me: How's your painting going?

Student: I don't know. I'm feeling confused.

Me: Great! Let's take a moment to bow our heads and give thanks to Our Lady of Holy Confusion for stopping by and blessing your painting process. So, what's confusing you?

Student: Well, I painted this pale blue-and-green sea cucumber, and now I'm feeling incredibly sad.

Me: OK.

Student: And it makes no sense that I would be feeling this sad from painting a sea cucumber.

Me: Well, it doesn't make sense to your mind.

Student: What's *that* supposed to mean? Where else *would* it make sense?

Me: It looks like it's making perfect sense to your heart and your body.

Student: Well, yes. That's true, but I need to know why it's making sense to the rest of me.

Me: Why?

Student: What do you mean, why?

Me: Why does it need to make sense to your mind?

Student: It just does.

Me: Does not knowing stop you from painting?

Student: No. (Said very sullenly)

Me: Does not knowing stop you from *enjoying* the painting?

Student: No, not that either.

Me: OK, then. So, I don't see the problem.

Student: You *never* see the problem, but now I have another problem.

Me: *Yeeess?*

Student: It looks like this ball of white in the middle of the painting is going to turn into another sea cucumber.

Me: That's fine, but how is that now a problem?

Student: If I paint another sea cucumber I'm going to feel sad again, and I don't want to keep feeling sad.

Me: Well, first off, you have *no* idea how you're going to feel when you paint that next sea cucumber. None at all. Secondly, if you *do* feel sad, it's just an invitation to keep opening your heart to yourself.

Student: So you're saying I should let myself feel vulnerable.

Me: If that's what's true for you in this moment, then yes.

Student: Oh my *God*. Now I get it. These are *vulnerability* sea cucumbers, but that makes even less sense than just feeling sad.

Me: To your mind.

Student: *That* again?

Me: Pretty much. It sounds like you're putting a lot of pressure on yourself around this painting. I have a tip for you.

Student: Oh yes! Please, a tip! That would be *so* helpful.

Me: Any expectations you have for this painting? You need to lower them, like, drastically.

Student: *Whaaaa?* That wasn't helpful at *all*.

Me: To your mind.

Student: What have you got against my mind?

Me: Not a darn thing. I just have problems with anything that gets in the way of your painting process. Your mind always seems to be furtively lurking somewhere in the vicinity whenever you get stuck. So, frankly, I don't trust it.

Student: But I can't just let my mind *go*! Can I?

Me: Through this conversation you have actually proven to me, without a shadow of a doubt, that you can do that very thing, and even feel good about it.

Student: What have I *done*?

Me: Welcome to the Empty Head Painting process, where what you think you know doesn't mean a darn thing.

Student: I think I was happier being totally confused.

Our allegiance to the need to make sense of our lives goes largely unquestioned. We simply assume that anything we create or any course of action we take, *must* be understood rationally in order for it to be considered valid. We sincerely believe that confusion, or being in the dark, even for a little while, is something to be avoided at all costs. But the capacity and willingness to be in the realm of the unknown is a very useful skill to have. If we can't tolerate being in the foggy zone, we can never move beyond what's comfortable and familiar and cultivate the courage to venture into those places where there's no map or step-by-step instruction guide for what to do next.

There may not be an actual map that we can hold in our hands, but we do have an internal guidance system to help us find our way when the way is unclear. We all come equipped with a compass of the soul, and that compass is our feelings, our desires, and our intuition.

If we follow our curiosity, our burning questions, our "what ifs?", our excitement, and our hungers, they will invariably take us on an adventure, leading us through the dense undergrowth and the shadowy forest of what we can't imagine into whole new worlds of renewed vitality and aliveness. But we'll never learn how to rely on that system unless we let go of always having to know where we're going and when we're going to get there.

1. What feelings, thoughts and beliefs come up when something appears that doesn't make sense to you in your painting process?
2. What scares you about the unknown?
3. What would it look like for you to simply hang out in the unknown without forcing meaning or understanding when you find yourself confused by what's showing up in your paintings, your art or your life?
4. Are you willing to give that a try?

13

NO MORE LEAVES

Me: So how's your painting going?

Student: Well, I painted this tree and then started painting leaves on the tree. At first it was really great and interesting, but now I'm not really into the leaves anymore, and yet I'm making myself finish them.

Me: You know, when it comes to this process you don't have to do *anything* you don't want to do, like, ever. It's such a great practice to pay attention, moment by moment, to what has the most aliveness for you *right now*. If it doesn't have that zing, that sense of connection in the here-and-now, stop what you're doing and go to where the juice is.

Student: But I *need* to finish these leaves.

Me: How do you feel as you're working on those?

Student: It's actually kind of a drag. Painting the rest of these leaves feels incredibly tedious. So, I'm feeling kind of tired and like I'm just going through the motions. I'm really wishing it were done already so I can go on to something else.

Me: I'm sorry to tell you, but we don't do that here. You can be bored and disconnected on your own time. This is the juicy aliveness workshop. Not the I'm-bored-out-of-my-skull-and-can't-wait-for-it-to-be-over class. I think there's one of those up the street.

Student: But I can't just *stop* doing these leaves. If I do that it's going to look all weird and imbalanced.

Me: So right now you're more concerned about how it looks than how it feels.

Student: Well, yeah. I guess I am, but it's OK. I don't mind. It will only take a few more minutes to finish them. Then I can get back to what feels good and fun.

Me: Let me ask you something: How many times do you do that same thing in your daily life? You know, keep yourself doing what you don't want to do because you think you're supposed to for some reason or another? Do you put off pleasure, fun, what has a real sense of aliveness and meaning for you for something that looks good, or gets you approval, or makes you feel safe?

Student: I don't think we want to go there.

Me: Why not?

Student: Because I do that *all the time*!

Me: And how does that feel?

Student: Kind of like I'm coasting and on automatic pilot, and waiting for it to be over.

Me: So here's the million-dollar question: is that how you want to spend your life energy? Being bored and hoping it's over soon?

Student: Of course not! You know, why don't you go and talk to somebody else now? You're bugging me.

Me: OK. I'll go, but only if you promise to stop painting those leaves.

One of the ways that we bring our creative curiosity to a grinding halt is by insisting that what shows up in our paintings follow some kind of rules. Maybe it's a rule related to things being balanced or ordered, or the rule that we need to finish what we start, or the rule that everything has to look realistic. We go to sleep to ourselves when we allow our allegiance to what we think *should* be happening push aside the creative truth of what *wants* to be happening.

Boredom is always a sign that we've gone off the creative rails. It should never be tolerated if we want to maintain our connection to what has the most aliveness for us. Following the rules gives us the illusion of safety. It promises us that we will be forever kept from harm. It makes being a good girl or good boy who lives for the approval of some outside authority more important than connecting with our own inner creative sovereignty.

Playing it safe when it comes to your art is ultimately a creative dead end. Even more importantly, it's not at all fun. If we want to remain creatively alive, we need to pay close attention to the ebbs and flows of our own unique creative rhythms and not let rules or expectations get in the way of the wonderfully idiosyncratic meanderings of our one-of-a-kind creative flow.

1. Make a list of the rules you have about painting. It might be something like everything always needs to be balanced and symmetrical. Or you can't paint something if it's not realistic. Or maybe there are colors you would never use together or colors you would never use at all.

2. What are you afraid would happen if you allowed yourself to break some of those rules?

3. Try it and see how it feels.

14

MORE RED

Me: So how's it going with your painting?

Student: Well, I'm really having fun with this red part over here, but there's an open white place on the painting that's really bugging me and I think I need to paint something there.

Me: Do you have juice for the open white space?

Student: No, not really, but I can't stop thinking it about it. It's driving me totally *crazy!*

Me: So, let me get this straight. You're having fun and feeling really alive painting the red, but your mind is obsessing about this blank spot on the painting. I'm just wondering why you would want to take your attention away from what feels so good and focus on this thing that's causing you all this agitation and frustration?

Student: Well, when you put it *that* way, it seems kind of obvious. I don't understand why I get so caught up in thinking I'm supposed to do something else, when I'm obviously having

such a fabulous time right here and now. Oh shit. Did you hear what I just said?

Me: Yup! Loud and clear.

Student: I think I need a drink.

Me: No, you just need more red.

When our obsessing, worried mind hijacks our creative process, we can easily become distracted by what we think *should* be happening in our art. That's when it becomes extremely difficult to tolerate things like empty spaces, or lack of balance, or perspective, or whatever else it is that the mind defines as a problem to be solved.

It's how the process of thinking keeps us out of the present moment, which is the only place where joy and pleasure lives. It's like we have an invisible pleasure and fun quotient, and when we get too close to the edge of our happiness limit, our judging mind comes in with a bag of tried and true diversionary tricks that keep our happiness from getting out of hand. Goddess knows what kind of trouble we will bring down on our heads if we let ourselves get *too* happy.

So, this is another place where we need to stay awake to how we continue to feed those happiness-limiting patterns. Ideally, we want to keep the focus of our attention on where we feel *good*, and follow the threads of delight. We would have way more fun if we willingly commit to the practice of choosing to bring ourselves back to what holds the most bliss for us, over and over again.

1. What messages have you gotten from your family, school or culture about joy?
2. What scares you about joy?
3. How do you distract yourself from your joy?
4. How do you support and deepen your joy?
5. What brings you joy?
6. Paint what brings you joy right now.

15

NEXT WEEK

Me: So how's your painting going?

Student: Well, apparently, I am really resisting this part of the painting.

Me: What's happening there?

Student: I *really* don't want to paint those black flowers I keep seeing in my mind's eye.

Me: Are painting those flowers where you have the most energy? If it is, you know what you need to do.

Student: I know. You're right. I need to just go *toward* what I'm trying so hard to avoid. Resistance is such hard work!

Me: Well, it's really good that you're seeing that.

Student: But I realized the same thing *last* week in painting class!

Me: And you'll probably realize it again next week.

Student: Are you saying I'm caught in this loop of resistance forever?

Me: No, I'm saying that you're in this for the long haul. You'll enjoy yourself a lot more if you simply allow yourself to relax and not take yourself, *or* your resistance, too seriously.

Resistance to your creative flow is one of those things you can absolutely count on whenever you surrender to your desire for more creative freedom. It's part of the predictable art-making dance where we find the thread and lose the thread of our creative aliveness over and over again.

It's important to remember that when resistance shows up, it's not a bad thing. It doesn't mean you did something wrong, or that it's game over. Resistance is just a signal that you've reached a place in your creative process where it's time to take some kind of creative risk, and you're scared to make the leap.

When resistance rears its stubbornly contrary head, it's a wonderful opportunity to turn what feels like a creative roadblock into a wide-open creative thruway. You do that by going *towards* what you're resisting instead of slinking away into massive creative avoidance.

So, if you are being asked by your muse to paint a cat, and you've never painted *any* kind of imagery before, your mission, if you choose to accept it, is to paint a cat, no matter how much you think you can't do it, or how awful you're convinced it's going to turn out.

Resistance wants us to stop experimenting and stop trying to do anything new, but both of those things are the lifeblood of the creative process, and without them we soon find ourselves

languishing in the creative doldrums. Using your resistance as a signal for what needs to happen next in your artwork and your life is a fabulous way to keep the creative wheels turning. Because one thing you can count on in your creative journey is that you will never run out of things to resist... or create.

1. What kinds of things are most likely to activate your resistance when you're making art?
2. What are your favorite forms of resistance? Do you distract yourself with social media, clean the house, rummage around in the refrigerator for snacks, etc?
3. How do you experience resistance? How does it feel in your body? What thoughts show up when you're in resistance mode?
4. What do you do to challenge your resistance when it shows up?
5. Challenge whatever resistance you're feeling right now by resisting your resistance!

MUPPET DEATH

Me: How's your painting going?

Student: It's totally freaking me out!

Me: Why is that?

Student: Well, my painting told me to paint Death in this corner.

Me: Yes?

Student: But first I needed to paint a unicorn.

Me: OK.

Student: And then Death needed to be riding the unicorn.

Me: Hmmmm.

Student: But I'm not so sure how I feel about the way that Death showed up.

Me: What do you mean?

Student: Well, Death is supposed to be serious, right?

Me: If you say so.

Student: But this image of Death that came out of *my* brush has a purple cape and a bad blonde wig and a Muppet face, and it's giving everyone the finger! It's like *Death, the Superhero.*

Me: So what's wrong with that?

Student: I didn't expect Death to be so *ridiculous* and *joyful*, and it's a *girl*. There's definitely bosoms poking out of the purple spandex. I got all this black paint to create a somber Grim Reaper *guy* with a hood, and I didn't use the black paint at all. I just think it's wrong to have Death be a Muppet!

Me: Sounds like you had some very definite ideas and expectations about what Death is supposed to be.

Student: Well, yeah. I mean, Death is Death. *Everyone* knows what Death *should* look like. Plus, won't I get in trouble around this? Painting Death as a superhero is kind of like blaspheming or something. Isn't it?

Me: Sounds like you're worried about the Death Image Quality Control Police.

Student: Exactly! I knew it! I *knew* there was such a thing.

Me: Hold your horses, sweet mama. If they *do* exist, it's only in your own fevered and runaway imagination.

Student: So you don't find this shocking?

Me: Shocking? No, not at all. I have no problem with a bleached-blonde version of Death. She's actually kind of cute!

Student: But maybe you *should* be shocked! Is nothing sacred around here?

Me: It depends on how you define sacred. If you're asking me if there is a concept, or an idea, or an image that is guaranteed to

be protected from change, or challenge, or transformation, or purple spandex? Uh... then the answer is no. Everything, and I mean *everything*, is fair game in this studio. On the flip side, *everything* is also sacred in this process, including your purple-cape-wearing, bleached-blonde, finger-giving, unicorn-riding Death girl.

So what comes next in this painting?

Student: I don't think I even want to know.

One of the best parts of the creative process is how it continually surprises and challenges us around how we think things are *supposed* to be. It shows you all those corners in your psyche where you unwittingly believe you have everything all figured out, and blows those unconscious conclusions out of the water on a regular basis.

When your understanding of the world is on lockdown in your mind, it inevitably leads to a sense of inner rigidity and creative stasis in both your being and in your painting. Being absolutely sure about anything is guaranteed to clog the creative pipes and cramp your creative style.

Your intuition uses the power of your imagination to show you how wrong you are to think you know *anything* about how reality actually works. It's always more than happy to turn your unexamined assumptions and expectations about the way you think things are upside down, keeping your creative energy fresh and moving and alive. If weird and improbable creatures or beings show up in your paintings, it's time to rejoice. It means

things are shaking loose in your soul in a big way, and true artistic freedom is just around the corner.

1. What are some taboo things you would never give yourself permission to paint? Make a list.
2. What messages have you gotten about painting those unacceptable and forbidden things?
3. Paint one of your taboo images or colors. Write about how that felt.

17

OTHER DIMENSIONS

Me: So how's your painting going?

Student: Well, I painted this weird body, and none of the organs are where they are *supposed* to be! The heart doesn't belong on *top* of the lungs, and the heart shouldn't look like a valentine!

Me: You have to remember that these beings that show up in our paintings often come from another dimension. So they aren't going to look like we look here on planet Earth. You need to be careful. You're right on the edge of some inter-dimensional chauvinism here.

Student: Holy crap! You're right! I don't want to piss off beings from another dimension. I have enough problems with those from *this* one.

One of my favorite sayings is "Reality is highly overrated" and nowhere is that more true than in the intuitive painting process.

If you are continually monitoring what images show up in your painting and demanding that they line up with what you already know about the world, it puts a major kibosh on your creative energy and your creative flow. Your imagination loves to play and to explore all kinds of alternative realities. Creativity is meant to be fun and a big part of that joyful experience is the willingness and ability to make shit up!

It's only the left brain/ judging mind that is terrified of the metamorphosis that occurs when you're gleefully opening yourself to the exhilaration of creative invention. It's afraid of anything weird or out of the ordinary and feels threatened by things it's never seen before. It's totally convinced that the world of the bizarre or outlandish is dangerous and so it tries to convince you as the artist that allowing these missives from the mysterious into your art means something terrible is going to happen to you.

Which of course, is NEVER the case. The more you can allow your wild and wacky quirkiness to come through your brush, the more engaged and inspired and excited you will be as you paint because you literally have NO idea what's going to happen next! Your painting process becomes an adventure into the unknown. And you become the daredevil trailblazer forging her way through the underbrush of your psyche and discovering new and enchanted trails into magical realms you had no idea existed. Until you became the courageous creator willing to invent them.

1. What is your definition of weird?
2. What did you learn growing up about imagination?
3. How much space and time do you give to activities like daydreaming or pretending or making things up?
4. In what ways do you limit your imagination?
5. In what ways do you allow yourself to express your imagination?
6. What is your imagination giving you right now?
7. Paint that.

NO REPEATING

Me: How's your painting coming along?

Student: I'm actually feeling kind of bored right now.

Me: That's no fun! When was the last time you felt excited about what you were painting?

Student: I was painting this big silver globe over here with teal-colored streamers coming off of it. That was a *lot* of fun, and then I stopped.

Me: Why in heaven's name would you stop painting something that felt so good?

Student: Well, I painted something almost identical to this image in my last painting. I thought I should do something different. You know, be more original. Not be so predictable and dull.

Me: Wow! That's quite a lot of pressure to put on one little piece of paper, as well as on yourself. You sure you didn't go to art school?

Student: No, I didn't. Plus, I was pretty sure that I wasn't supposed to paint the same thing twice.

Me: Actually, you're right about that. I forgot to mention that in the orientation.Each person is only allowed to paint any given image once. No repeating.

Otherwise, it's forty lashes with a squirrel-hair paint brush.

Student: I guess I kind of made that rule up.

Me: It sounds like maybe you did.

Student: I'm realizing that all these rules and expectations are designed to do one thing.

Me: And what is that?

Student: They are all designed to keep me from doing whatever it is that I *want* to do.

Me: Well, that certainly sucks! So what do you want to do right now?

Student: Whatever the heck I feel like doing! Sometimes I can't believe this process. Is it really that simple?

Me: It really is. Paint what you like again and again. Be happy. End of story.

Student: You probably hear these same issues all the time. Doesn't it drive you nuts?

Me: Not really. I do love watching people get free of these inner mind-shackles, and I am gratefully blessed with some pretty remarkable patience, but I'm old. I have no memory. So, every time I work with someone, even if they are telling me a story I've heard a million times before, as far as I'm concerned it's a brand spanking new experience.

The belief that we have to continually be doing something new when we're creating is another one of those sneaky inner-critic tricks designed to throw us off balance and is related to the need for outer approval and attention. When we get caught in that particular loop, it's useful to ask the question, "Who are we trying to please with all this novelty? Who do we imagine is expecting us to produce this perpetual supply of ingenious and inventive creations?"

The incessant pressure to be creatively exciting and original is based on the deep-seated anxiety that we *must* stay fascinating and compelling to someone other than ourselves, because if we don't, these mysterious others will lose interest and walk away. If that happens, we fear that we'll feel abandoned and rejected. That lack of attention from an outside source will be proof positive and confirm our worst anxieties that our creations...and ultimately who we are...has no value.

In those moments, we forget the sacred truth that our creative process is fundamentally for *us*. Its primary purpose is to feed and nurture and express our deepest selves, for ourselves. Whether or not it provides value for someone else is a happy byproduct of our authentic creative expression, and that includes joyfully painting anything at all, for no apparent reason, again and again and again.

We don't have to gain attention from an outside source in order to experience that sense of deep satisfaction and pleasure. All that matters is what *we* feel as we create. If we are enjoying ourselves, that is *more* than enough.

1. What comes up for you around being creative simply for your own enjoyment?
2. Who do you wish you could get approval from when you're making art?
3. Take a moment to be with your painting and instead of worrying about being original just notice where you felt the most creatively alive.
4. Make a list of your natural creative gifts.
5. Celebrate yourself for making that list.

ONE BRUSH CLAPPING

Me: So how's it going with your painting tonight?

Student: I'm really, really upset.

Me: What happened?

Student: Well, I was painting along just fine, and really enjoying the process, and then some paint accidentally dribbled from my brush. Now there's a big old glaring drip right in the middle of my picture.

Me: So what's next?

Student: What do you mean? Nothing happens next. I need to fix the drip, but I can't because the paint will smear and just make a mess.

Me: Where else are you drawn to paint on the painting?

Student: I *can't* paint anywhere else. I can't stop looking at that drip, and I can't do anything else until I figure out a way to fix it. It's not supposed to be there, and it's totally ruining my painting!

Me: But you can't fix it.

Student: I know. That's what's making me absolutely crazy.

Me: Is that drip the most alive place for you right now?

Student: Well, it sure is awfully frustrating.

Me: But is it the most *creatively* alive?

Student: Well, no. I wouldn't say that. I'm actually feeling like I've come to a screeching creative halt.

Me: I think I know what happened. It sounds to me like your perfectionist has hijacked your creative self, keeping you obsessed, mesmerized, and stuck on something you can't do anything about and that has no juice for you anyway. But you are refusing to let go of the idea that you can change the past and simply allow yourself to move forward into the future where you can continue joyfully creating.

Does that ring any bells?

Student: (Stares at me with a glazed look on her face)

Me: You OK?

Student: I think something just short-circuited in my brain. I have no idea what to say in response to your last statement. Words fail me.

Me: Fabulous! No words is a *great* thing! Now you can get back to painting instead of arguing with your painting.

Student: You sure this isn't a Zen Painting class? I feel like someone hit me in the back of the head with one of those wooden Zen sticks. I'm not exactly sure what you said, but all of a sudden that drip no longer matters.

Me: Welcome to One Brush Clapping!

How many times have you allowed yourself to get stopped in your creative tracks by what you thought of as a mistake? When we think we've screwed something up, we can get waylaid by a boatload of self-recrimination peppered through with feelings of shame. We become bound and determined to stop the painful feelings by doing everything in our power to make the supposed mistake go away. Becoming fixated on the mistake only feeds the shame cycle, intensifying it, and making it even *more* extreme. Focusing on what you *think* went wrong gives you the message that you actually did something wrong, and that there is something wrong with you, which isn't even remotely close to the truth.

There are truly no mistakes when you paint. There are only endless opportunities to create, endless opportunities to respond to what shows up on the canvas with curiosity and resourcefulness, and endless opportunities to be led down paths you would never have gone on if the "mistake" had never happened. Perceived mistakes are always a doorway into the mystery and the unknown. These mistakes are a portal into even *greater* creative possibilities if you just get out of the way and let them lead you there.

1. What is your definition of a painting mistake?
2. As you paint take a moment to notice when you think you've made one of these mistakes or ruined your painting.
3. Instead of automatically jumping in to fix that supposed mistake, take a breath and simply don't do anything. Just pay attention to whatever feelings or thoughts are coming up around this mistake. Take a moment to write those down.
4. What other creative impulse came out of not automatically fixing the supposed mistake?

RELUCTANT PINK-HEART LOVE

Me: So how's your painting going?

Student: I think my intuition hates me.

Me: Why would you say that?

Student: Well, all it wants me to do is to paint these stupid hearts.

Me: Hmmmm...

Student: And not only that, it wants me to paint *pink* hearts! I *hate* pink. Pink is not my color at all. I would never choose pink if it was left up to me.

Me: I see. You obviously have quite a strong reaction to those pink hearts.

Student: You better believe it. I'm simply not a pink-heart type of person. I'm strong, and tough. I don't let anybody push *me* around.

Me: So you think that painting those hearts means something about you?

Student: Well, doesn't it?

Me: Maybe yes, and maybe no. Even if they *do* mean something, it sounds like you're not making a lot of space to really find out what that might be.

Student: Well, what else *could* they mean?

Me: I don't know, but maybe a better question to ask is, How did you feel *as* you painted them?

Student: Feel? You want me to talk about how I was *feeling*, now?

Me: Uh... yes, I do.

Student: Well, I actually felt kind of quiet, and happy, and soft. I don't *want* to feel soft.

Me: How did you feel about the softness?

Student: I kind of enjoyed it, but I don't *want* to enjoy it. I don't want to be the person who paints pink hearts and feels soft and likes it.

Me: I think it might be a little late for that.

We are filled with so many stories about who we think we are or who we think we're supposed to be. Those stories may have been true and useful at one time, but at a certain point they become terribly limiting. We need to be reminded on a regular basis that life is a constant process of growth and change, and to make sure we allow ourselves to embrace that ongoing transformational process.

That's why our intuitive, creative self is always pushing us out of those old stories and into newer and more updated versions of ourselves. However, it's pretty much guaranteed that the new territory is going to feel kind of squirmy and uncomfortable.

The stories we are identified with are usually dust covered and ancient and based on some outmoded, second-hand version of who we are now. These stories are like last decade's fashions and don't allow us to claim the truth that we are often so much *more* than what we believe about ourselves.

When you find yourself attracted to, or excited by, something outside of what you would consider your normal way of being, it's a sign that some other part of you is finally waking up and wants to join the party. So open the door. Welcome it in. If you're painting it, it's already a done deal. You're just the last person to know, and there's no going back now!

1. What are some things you could never imagine allowing yourself to paint because they don't fit with your current self image and make you feel uncomfortable?
2. Make a list of those things.
3. Choose a couple of things on that list, paint them on purpose and see what comes up.

SCARY RED HEARTS

Me: How's your painting coming along?

Student: Well, I'm kind of at a standstill, because there's something I need to paint and I don't want to paint it.

Me: You want to tell me what it is?

Student: It's pissing me off.

Me: OK. So something that you know you need to paint and yet don't want to paint is pissing you off, and you're not ready to say what it is.

Student: No, no. I'm ready. I'll tell you. Do you see this creature here at the bottom of the painting with its mouth halfway open?

Me: Yup. I sure do!

Student: Well, it looks like I need to paint red coming out of its mouth. I'm not sure what the red thing is, but I think it could maybe be a tongue, or something else.

Me: Like what?

Student: Like blood.

Me: And you don't want to paint that?

Student: No, I don't. I'm pissed because I was having so much fun with this painting and feeling so good, and now this bloody, red thing is showing up. Why does the shitty stuff always have to come into my painting at some point?

Me: What I actually heard you say initially was that red needed to come out of the mouth, but then you started trying to figure it out and name it. Now you have a story about the red and what it means, and it sounds like it's what you think the red means that's pissing you off. How did you feel when you simply got the directive to paint red? No story?

Student: I felt kind of happy, and excited.

Me: So, maybe you don't really *know* what this red thing is that's coming out the mouth. What if you just let yourself trust the brush, paint red, and be surprised by what shows up? How would that feel?

Student: That sounds a whole heck of a lot better. I wouldn't feel so stuck. Maybe it's not blood. Maybe it's something totally different. Maybe it's... OH NO! Shit! Now I see exactly what it is. It's whole bunch of red hearts!

Me: How does *that* feel?

Student: It feels absolutely right. Dammit! Those red hearts are even *worse* than the blood.

Me: Why would you say that?

Student: Well, they're so kitschy, trite, and completely uncool.

Me: You really *do* have a problem.

Student: I'm glad to hear that you're agreeing with me for once!

Me: About what?

Student: About hearts being uncool!

Me: Oh, I'm not agreeing with *that*. That's not your problem. Your problem is that you can't stay out of your head and keep from telling yourself scary stories long enough to simply pick up the brush and paint.

We have a tremendous attachment to making meaning when we are making art, and have a hard time trusting that spontaneous expression without intellectual comprehension has any value at all. We are convinced that we have to understand what is happening in our paintings every step of the way. We firmly believe that we can't risk making a mark on the canvas unless we are clear as to *why* we are doing it, where it comes from, and where it's going to ultimately lead us. If the meaning doesn't reveal itself to us immediately, or ever, we try to force the meaning. This keeps us running around in circles in our heads, not creating anything until we have a clear grasp about what we think an image, shape, or color signifies.

The intuitive painting process is profoundly meaningful, but sometimes it's a *felt* meaning that doesn't always make sense to the thinking mind. Sometimes the meaning is alive in the body, or the emotions, or on a spiritual or energetic level that is happening beyond our mind's ability to perceive it. We need to practice letting meaningless experiences be OK. We need to open ourselves to the possibility that our mental processes are

not the only game in town. It's *good* to be willing to simply allow our intuition to lead the way while making space for the irrational, the non-logical, and the unreasonable, as we open our hearts and minds to what we can't know, or, sometimes, *ever* understand.

1. What did you learn about being spontaneous in your paintings, your life or your art?
2. What comes up for you when you allow yourself to follow your unplanned impulses?
3. When have you noticed censoring yourself when you got the intuitive prompt to paint something that you didn't understand?
4. What would happen if you painted it anyway?

22

THE EYES AND THE PLAN

Me: How's your painting going?

Student: It's OK, but I think I hit a bit of a snag. I'm not always sure when my intuition is talking to me and when it's my judging mind. So, how do you tell the difference?

Me: Well, the judging mind always uses certain types of language like "should" and "supposed to" and "ought to." It's also a dead giveaway when you hear it say something is "too" anything, like too much, too big, too bold, too intense, too pretty, stuff like that.

Student: Uh-oh. I think the judgments did sneak in and take over. I was actually happily painting all these eyes over here, and then I heard this voice saying "That's too many eyes."

Me: So what did you do?

Student: Well, I stopped painting the eyes.

Me: And how did that feel?

Student: Like I just ran out of gas and I didn't want to paint anymore.

Me: So what do you think you need to do now?

Student: Paint more eyes?

Me: Is that where the juice is?

Student: Hell *yeah!*

Me: Then I think that sounds like a very good plan.

Student: I thought we weren't supposed to plan?

Me: Don't worry. I think you can get away with it this one time. Your secret is safe with me.

Knowing the difference between the judging mind and intuitive guidance is generally a bit confusing when you begin this journey of paying attention to your inner world through the intuitive painting process. But a good rule of thumb is that the intuition is always calling you forward towards creative expansion. The intuition wants us to thrive, bloom, and become our whole and wondrous selves. It's always an invitation to say *yes* to some part of you that is longing to be expressed. Sometimes it's a *scary* invitation, but that's just the fear of stretching into something new and different and often unfamiliar. We don't know exactly where this invitation is going to lead us but by following the yes we are always guaranteed a greater connection to our juicy aliveness.

The judging mind wants to *stop* that forward movement because it doesn't trust anything that it hasn't seen before. It uses the scary feeling that always comes when you're contemplating a creative risk as an excuse to say *no* to those often-unnerving soul-entreaties into what will ultimately allow us to grow, heal, and flourish into the big, bright beauty of our essential being.

1. The next time you paint notice how often you use words like should or supposed to around choices you make in your art.
2. Pay attention to how those words make you feel in your body.
3. See what would happen if you put a moratorium on allowing those words to influence you and simply didn't paint what they told you to paint.
4. Instead, only paint from where you feel a sense of YES!
5. If you allowed yourself to believe that anything could happen in your painting, no holds barred, what would you paint next?

THE ROCK

Me: How's your painting coming along?

Student: The only thing that has any energy for me is to paint a rock in that corner.

Me: So, paint a rock in that corner.

Student: But I don't *want* to paint a rock. It's a stupid idea. It doesn't make sense. I'm afraid that if I do it will totally ruin the painting.

Me: Is the creative juice in painting the rock?

Student: Yes. That's the only place I have juice.

Me: Then paint the rock.

Student: You always make it sound so simple!

Me: That's because it *is* that simple.

Student: (Grumbles for a while but paints the rock)

Me: So, how was it to paint that?

Student: It was actually great to paint that darn rock. Now I really like the painting. You were right. Again.

Me: You'll get used to it.

Student: So, now I'm bitter but happy. (Said with a smile)

The judging mind is constantly trying to complicate *everything*. It has a hard time accepting that things can be as straightforward as they truly are. Because its orientation to life is always based in fear of the future, it's not grounded in any kind of current reality, which means it can't ever trust its own perceptions. It's a master of second-guessing and questioning what it thinks because it never truly knows.

Because the intuition *is* grounded in the reality of love and an ability to *be here now* in the present moment, it always knows *exactly* what to do next. It can't always tell us how it knows, but it has a certainty that we can feel in our body and our heart if we're truly paying attention.

That certain knowledge makes it a huge fan of simplicity, because the next step is always simple, and can often surprise us with its startling grasp of what, in retrospect, is completely obvious.

So, when you "can't make up your mind" about a question or a dilemma, simply stop. Breathe. Take a moment to listen and to hear that still small voice of clarity that is always present, waiting to guide you towards what is usually right there in front of you. Then simply do that thing, and feel the sweet relief of

reconnecting with your always-present, always-available, ever-generous creative source.

1. Take a moment to stop, breathe and simply be here now with yourself and your inner experience.
2. What kinds of resistance come up when you read this prompt?
3. Once you get over your resistance, what do you feel and sense on the body and emotional level when you take the time to do this?
4. From this place of deeper connection with yourself, come back to your painting and see what shows up and wants to be painted.

THE THIRD CHOICE

Me: So how's it going with your painting?

Student: I think I might be done with this painting.

Me: So you're feeling like it's complete?

Student: I don't know about *that*. I just *want* to be done with it.

Me: And why is that?

Student: Well, I really like it. It's the coolest painting I've ever done so far, and I don't want to mess it up.

Me: So, what could you do that might mess it up?

Student: Oh no. I'm not answering that question. You *want* me to mess it up.

Me: No, I just want you to keep painting.

Student: If I tell you you'll make me paint it.

Me: I can't *make* you do anything. But I will encourage you to paint this thing if it has energy for you, and you can't blame me.

It's your *muse* that wants you to paint this next thing that you're afraid will mess it up. I'm only here to support your muse.

Student: Well, my muse has no sense of aesthetics.

Me: What makes you say that?

Student: I keep thinking about painting black in between these purple flowers, and you should *never* paint pure black in your painting.

Me: Where did you get that idea?

Student: I don't know. I think I read it in a book somewhere about famous artists.

Me: You should probably stop reading those books for now. So, what if you let go of what someone else thinks about this and just paint the black?

Student: *Noooo!* That's going to really wreck it! Black is such a *negative* color and this painting is really happy.

Me: Wow! Sounds like you've got quite a few opinions about this black. You've got it all hemmed in by a bunch of rules, and you're ascribing really intense meanings to it when it's simply a color. That poor black doesn't stand a chance with you. Also, you think you have a crystal ball predicting the future about how you will feel if you paint the black.

Student: I just don't want to ruin this painting, and I'm really afraid if I paint that black that's exactly what's going to happen.

Me: Maybe you will. There's no guarantee about that, but the question really isn't "Am I going to ruin this painting or not?" The only question is "Do you have energy for the next thing that wants to happen?" In this case, the next thing happens to be the black.

Student: I hate that question! But yes, I have tons and tons of energy for the black.

Me: OK then. That sounds pretty clear.

Student: When you say it like that, it sounds like I don't have a choice!

Me: You *always* have a choice. You can choose to be fully alive in this moment and take a creative risk, or stop everything to protect something that's already dead and gone and in the past.

Student: You sure there's not a third choice?

Me: I'm really sure. This is it. The only one you've got, and the only one that really matters.

Getting to a place in your art where you really *like* what's happening can be very dangerous to your creative aliveness, because that's when you start to hold on for dear life to the beauty or meaning of what you've created, refusing to take another step forward for fear of screwing up, messing up, or, heaven forbid, *ruining* your gorgeous creation. We forget that the first rule of being on this planet is that everything is in flux all the time. Impermanence is the name of the game. Our creative energy is continually flowing through us like a river, and will only keep flowing if we are willing to freely express it.

When we get stuck in grasping mode, it's because we believe that nothing we create will ever be that good again. We lose our faith in our ability to *keep* creating magic, brilliance, and love. We believe the stories that we tell ourselves that we are limited

in our creative genius. We convince ourselves that the creative well will eventually run dry.

But you can rest assured that it's literally impossible for that to happen. Your creative capacity is essentially unlimited. You couldn't exhaust it if you tried. It is true that you are going to have different feelings and opinions about everything that you create. Some things you'll like. Some things you'll hate. Some things will confuse or surprise you. Some will bring you to your knees in awe. But ultimately what matters is that you *are* creating. Creativity is where your life force energy lives. And creativity is also another way of opening to love. Your connection to the river of life and love is deeply woven into the act of making your art. It's inherent in the inspired energy you bring to your creative journey. The gorgeous, or hideous, or confusing finished product is merely a memory of where you've been on your creative adventure. It's never, ever the adventure itself, and the adventure is the only thing that really matters.

1. Pay attention to how you feel in your body when you like something or don't like something that shows up in your painting. Just notice what happens internally when you're in either of those modes.
2. What it is that makes you either like or dislike something? Write about what you discover.
3. Make a list of things that bring up those feelings of dislike or that you fear will ruin your painting.
4. Take the risk to paint something from that list.

25

THE TRICK QUESTION

Me: So how's your painting going tonight?

Student: Well, I started off wanting to paint something really important.

Me: Yes?

Student: And I wanted to do it *right*!

Me: Hmmm...

Student: And I also want to know *exactly* where this painting is going.

Me: So, how's all that working out for you?

Student: Well, it's creating an awful lot of tension while I paint.

Me: Is that how you want to feel?

Student: Are you a crazy person? *Of course* I don't want the tension. I just want it to be important, and meaningful, and *good and FUN!*

Me: Ahhhh. So, you want it to be fun. When does it feel like the *most* fun?

Student: Is this a trick question?

Me: Would I do that to you?

Student: Yes, you would! OK. It's the most fun when I let go of needing it to be important, and meaningful, and good.

Me: OK! So now it's up to you. Do you want tension or fun?

Student: I knew it! That *was* a trick question!

What we long for is an ongoing experience of joy. The truth is that our connection to joy is always available, often right there in front of our noses. Contrary to many of the messages we get on a daily basis, we don't have to become something more than we already are in order to claim that joy. We deeply believe the cultural philosophy about how *hard* we have to work to get it. We have bought into the worldview that tells us that struggle and effort is the name of the game. We hardly ever question the assumption that the only way we can get to where we want to be is through striving and stressing. We take as gospel truth the idea of no pain means no gain, and take for granted the notion that *of course* we always have to push, and push, and push, to be *better*, as if better is even possible. How can we be better than who we already are? What does that even mean? We can only be ourselves, every minute of the day.

It's so hard to trust in the ease, the flow and the inherent grace of our being. We struggle to believe in the essential worthiness of

our natural way of expressing ourselves. We can hardly wrap our heads around the idea that if we simply do what feels good it's enough. But that's what the creative process has to teach us. It's an ongoing reminder that who we are right here and now is enough. Always. And that choosing to remember our enoughness is the surest pathway to creative joy.

1. What have you learned in your family or your culture about hard work?
2. How do you create the experience of stress and struggle when you're making art?
3. What kinds of things come easily to you when you're making art?
4. How do you value your art differently when it comes easily to you?

26

UNHINGED

Me: So how's your painting going?

Student: I *hate* this painting!

Me: What happened?

Student: Well, look what showed up! There are these three purple, alien, dancing television robot things that came into the painting. I don't like them *at all!*

Me: Wow! That's quite an intense reaction!

Student: Well, they *are* kind of intense.

Me: What don't you like about them?

Student: I don't know. They're weird, and ugly. They *just don't belong* in this painting.

Me: Well, oftentimes, when we don't like something in our painting, what we *really* don't like is how the thing that has showed up makes us feel. So, what do these purple alien robot things bring up in you?

1. How willing are you to be curious about EVERYTHING that shows up in your painting from a place of non-judgment?
2. What are the types of things that appear in your paintings that you have the most difficult time accepting?
3. Why is that?
4. What scares you about letting go of control in your paintings or your life?

TURQUOISE SNAIL

Me: So how's your painting going?

Student: I'm kind of stuck. I have no idea what to do next in this painting.

Me: When did you find yourself getting stuck?

Student: Well, I was out walking the other day and I stopped to watch this snail, and it was so very beautiful. The shell had all these amazing colors. So, now I painted the snail but I don't know how to paint the shell.

Me: What do you mean when you say you don't know how?

Student: Well, I don't know where to start. I want to get the amazing *feeling* of awe that I had looking at the snail to be represented here in the painting, but I don't know how to do *that!*

Me: It sounds like you're trying to make the painting reflect the feeling, and continually judging whether or not it's measuring up. It's like you make a stroke and then you say to yourself, "Did

it capture it? Is that the right color? Is it coming across?" Over and over again.

Student: Wait a minute. How did you know that? That's *exactly* what I've been saying to myself.

Me: Let's just say I've seen this problem before—like, a million times.

Student: I'm glad to know I'm not the only one, but it feels really important that I get this *right*! I want the snail to be proud!

Me: That's a lot of pressure to put on one little snail painting. Plus, asking those questions keeps you *out* of your direct experience by constantly monitoring what's happening and trying to get your painting to live up to the Awe Standard. No wonder you don't know what to do next.

So, if you simply *feel* that experience of awe, right now, what color do you see?

Student: Oh, that's easy. I see turquoise.

Me: OK! So now all you need to do is get some turquoise, move the brush on the paper, and allow yourself to feel the feeling *as* you paint.

Student: Oh my God. You're right. I remember now. I *have* been here before, and that "paint as you feel" thing always works *when* I remember to do it. You know, I've been painting with you now for over a year and it's always the same things that come up over and over again, isn't it?

Me: Pretty much.

Student: What's amazing to me are all the different ways you can find to forget the thing that you once knew!

Me: It's really the only way that the inner critic *ever* gets creative. It's stunningly good at finding a thousand different ways to clog your brain with very compelling stories about how complicated the simplest things have to be.

Student: What I don't understand is why it is we keep listening to it.

Me: If either of us ever finds out the answer to that question, we can comfortably retire to an island of our choice, and paint our turquoise hearts out!

There's a beautiful intimacy that can be cultivated with our creative soul through the intuitive painting process. Our paintings are a reflection of who we *really* are. By feeling *into* the painting, we feel into our true selves. And through making that connection with what is genuine, vulnerable, and authentic, we have the opportunity to fall madly in love with *us*.

We block that opportunity for intimacy by getting fixated on doing things in what we believe is the right way, because we can't believe that we're OK exactly as we are. Our fretful concern with perfection and appropriateness keeps us in a continual state of anxiety, which inevitably leads to a profound disconnection and separation from our hearts, bodies, and emotions. As well as cutting us off from our intuition, our creative process, and ultimately our sense of joy and awe.

But this intuitive painting process brings us back home to ourselves through the sacred portal our feelings. And reminds us that those feelings are credible and reliable and powerful,

and all we need in order to connect with what is most real and true and alive in our essential being.

1. What are ways that you are convinced you are not enough in your art and in your life?
2. Where did those messages or beliefs about your not-enoughness come from?
3. How do you feel in your body when you're trying to make something perfect in your painting?
4. What are you afraid will happen if you let go of that need to be perfect?
5. What happens in your body when you open to the idea of trusting in the process of how your creativity unfolds without trying?
6. Allow yourself to practice painting from that place of trust.

WHICH FACE

Me: So how's the painting going?

Student: I really get confused trying to tell the difference between my Mr. Judgy voice and the voice of my Creative Muse. Can you give me some tips on how to figure it out?

Me: OK, sure. I want you to think of something that would be really boring or difficult to paint. Something that you think you *should* paint because you want someone else to like it, or you're trying to prove what a good artist/person you are. Do you have something in mind?

Student: Yes. I see this vase with flowers in it, and a pale blue background. The flowers are roses, and I have to paint a million thorns on the stems. Everything is washed out and pastel, and I have to make it pretty and totally perfect.

Me: That *does* sound bad! So, as you think about painting this, I want you to notice what's going on in your face.

Student: My face? What do you mean, what's going on in my face? What does my face have to do with painting?

Me: Humor me. Just feel what's happening in your face. What it looks like from over here is that your lips are all puckered up, your eyes are squinty, and your forehead is crumpled. You've got a definite frowny face. Can you feel it?

Student: Well, now that you mention it, I can. It doesn't feel very good.

Me: I bet it doesn't. Now think of something that would be really fun to paint right now.

Student: I would love to take a *big* brush and paint *huge* swirls of yellow all over this blank page!

Me: What's happening in your face right now?

Student: So we're back to the weird face thing.

Me: Unfortunately, yes we are.

Student: Oh my goodness! I think I'm smiling! My eyes feel open and kind of sparkly.

Me: So, there you have it.

Student: There I have *what*? What the heck are you talking about?

Me: The answer to your original question. Your frowny face shows up when Mr. Judgy is running the show. The smiley face appears when your Creative Muse is leading the way. So, it's actually very simple. If you've got the frowny face, don't paint that thing you're thinking about. And if you've got the smiley face, then go for it!

Student: Has anyone ever told you that you're a total lunatic?

Me: It's part of the job description.

We are taught to believe that the only credible form of intelligence is what manifests in that space between our ears. We get the societal message incessantly and from an early age that our thoughts about any given situation are the only truth worth knowing. But underneath all that cultural conditioning we are continually getting all kinds of wise and helpful information from our emotions and our internal energy systems. *Those* truths are expressed through our bodies, our hearts, our bellies... AND our faces.

We just need to learn to tune into and *value* that information. That happens when we pay attention to what we feel instead of only what we think, and choose to notice our feelings and sensations as another equally valid form of knowledge and communication.

We are often cautioned to ignore and even denigrate our physical being including the myriad complex sensations in our bodies, like tightness or tingling, vibrating or pulsing. If we *do* pay attention, we are told those inner cues are meaningless at best, and the sign of some kind of physical problem or illness at worst. We invalidate our gut hunches as fantasy. We disregard our instincts as useless noise that are an aspect of our crude and messy animal nature. We reject our natural impulses as immature and dangerous aspects of our being that we need to keep under control.

Sadly, this is such a waste of incredibly helpful information, since each and every one of these physiological and energetic cues emanating from our embodied intelligence is telling us

something about what we need, what we truly desire, and what steps are called for next on our journey in order to *get* what we want. These living fluid phenomena that get expressed directly through our bodies are all part of how our intuitive wisdom speaks to us.

It's all right there. It's *always* been there. All we need to do is tune in and listen. These feelings and sensations are powerful and trustworthy messengers from our internal guidance system and are designed to help us navigate our lives in the most fulfilling, satisfying and creatively alive way.

1. What have you learned from your culture and your family about listening to your body sensations as a source of information?
2. What is your relationship to your body as your inner guidance system?
3. What kinds of practices, places or situations allow you to access your inner guidance via your body?
4. Take a moment to close your eyes and tune into your body right now in this moment. Feel what you feel. Allow yourself to paint from that place of pure feeling and sensation.

DUST BUNNIES AND PLUMPING PILLOWS

This student has painted some huge multi-colored tears raining down out of an even more huge eye. When I talk with her, she is in the middle of outlining the tears in black.

Me: How is your painting coming along?

Student: Well, I'm painting these black lines.

Me: Yes?

Student: I'm feeling kind of brain-dead while I'm painting them.

Me: Hmmm... OK. I'm going to challenge you to stop painting those lines immediately and remind you that one of the things we do here in this process is to pay attention to where we feel the most alive, and to *stop* doing anything that doesn't feed that sense of aliveness. The last time I looked, brain-dead is kind of the opposite of aliveness.

Student: But I *can't* stop painting them! Not until I've finished them all. If I stop now, the painting is going to look all weird and imbalanced. I have to make sure it's *perfect*, *then* I'll paint what feels alive for me.

Me: But sweetie, that's not true. You actually *can* stop painting them. It sounds to me like what we're really talking about is choice. You have that choice. You can either continue to stay with what is boring and tedious for the sake of perfection, or you can choose to be alive and engaged right here and now as you paint. It's completely up to you.

Student: (Looking distressed) This is really hard. I'm not sure I can do it.

Me: I know, I know. It can feel incredibly hard when you're on the brink of making a big shift in perception like this one. Let me ask you something: Does this issue come up for you anyplace else in your life?

Student: Oh my goodness, *yes*. This happens to me all the time at home. I won't let myself go to my studio and create until every dish is washed, every pillow is straightened, and every dust bunny is vacuumed up. Of course there's *always* something more to do around the house, so I never get to my studio. (Starts to cry)

Me: So, what are you feeling right now?

Student: Sad and defeated. This isn't how I want to live, but I don't know how to break free of the voices that tell me that I don't deserve to do art unless I have done everything else perfectly.

Me: I'm going to suggest that you have a powerful opportunity, right here and now, to practice standing up to those voices and letting go of that need to be perfect. You can do that through the painting process. It's totally up to you. So, are you ready to be creatively alive?

Student: (Still crying, but determined) Yes. Yes, I am.

Me: OK, so here's the question, and it's quite simple. Tell me one thing that can happen next in this painting that would feel like creative freedom.

Student: (Eyes widen) Oh my goodness! I think I can see it! I could stop painting the lines and fling red paint onto the paper.

Me: How does it feel to think about doing that?

Student: Scary, but exciting. I'm kind of tingling all over. Seriously, though, can it really be that simple? You know, I've been dealing with this issue for my whole life.

Me: Yes, it really can. This kind of stuff can shift in the blink of an eye when you're ready, and it looks to me like you are *so* ready. Congratulations. I think you've just broken a huge pattern. Creative Freedom is just a spatter of red paint away!

The biggest problem with perfectionism is that it keeps you separated from your true self, your fundamental nature and your core essence. When we are trying to be perfect, we are believing the lie that who we are intrinsically is simply not OK, or good enough. This kind of perfectionistic striving fills you with incredible self-doubt. It promotes a lack of trust in your inherent goodness and value, and ultimately leads to you abandoning yourself.

It keeps you caught on the hamster wheel of endlessly trying to be something that you're not, never can be, and probably aren't really all that interested in.

Striving for perfection is the opposite of trusting yourself. There is so much effort and stress and strain related to perfection, and it disconnects you from the experience of ease and flow and simply being without doing.

Perfectionism is deeply related to the desire for approval from an outside source. It's that continual search for external validation of our basic worth. And the really crummy thing about it is that most often, the source we are looking to *for* the approval is usually exactly the source that is totally incapable of giving us what we need. So we get caught in that incredibly painful loop of continually striving to get something that is unattainable.

Perfection is also about trying to live up to an external standard, and these standards are always impossible to achieve. Perfection keeps you locked in comparison mode, where you are always asking yourself the question, "Am I measuring up?" And of course the answer is always, always, "No."

If reading this is making you feel a sense of futility and despair, then you are really getting it. Those feelings of helplessness and hopelessness are where perfectionism always leaves you in the end, and I'm certain it's not where you want to be.

Releasing our compunction to be perfect allows us to experience the sweet satisfaction of simply being real. And being real is where our authentic creativity lives.

1. What are some of the standards that you are continuously trying to live up to when you are painting or making art?
2. Where did those standards come from?
3. What do you feel or experience when you are caught up in trying to achieve those standards?
4. How often do you actually succeed in reaching those standards?
5. Are these standards actually in alignment with your true values?
6. What would happen if released your compulsion to meet those standards? Try it and see how you feel.

ART-SCHOOL SHACKLES

One of my students is a professional artist and is trying to figure out how to reconcile intuitive painting with her art-school education.

Me: What's happening here with your painting process?

Student: I know that you talked about letting go of mental constructs and aesthetic concepts this morning in the class lecture, but I *like* it when things are balanced and symmetrical. It's incredibly pleasing to my eye. There are times when that conceptual language really helps to guide me in my process. Are you saying that I should never use those ideas again?

Me: I'm not saying that at all. You have that language available to you because of your training, and you should use it *if* it also aligns with your intuitive promptings. But that language can also be a cage and a trap. The purpose of many of those concepts is to help you maintain control so that you can reach a desired outcome. They don't always leave room for messy, astonishing, creative surprises, or authentic expression. If you *always* follow those rules, you end up painting like everyone

else, and I seem to remember you telling me that the reason you came to this workshop was to regain your creative passion and unique creative style.

Student: Yes, you're right. I want to feel like I can create like *myself* again, but I get caught in the desire to be a "good artist." I want to get approval, and I want to sell my art!

Me: Exactly, but how does it feel when you're always following the rules and painting in the way you've been told you are supposed to paint?

Student: Dead. Frustrated. Disconnected. It's no fun anymore. I desperately want to feel that sense of freedom and possibility and excitement again.

Me: So that means you have to constantly be mindful of when your art-school training supports your sense of creative sovereignty, and when it *inhibits* your creative freedom. It's time to continue to choose liberation over socially-approved aesthetics. You need to become a creative rebel and a revolutionary artist!

Student: Well, when you put it *that* way, how could I possibly refuse? Death to the color wheel! I've going to do things *my* way from now on!

Intuition and technique in our art making doesn't have to be mutually exclusive. That is never the case. Artsy techniques can be a fun way to play and express yourself. It's just important to have the techniques be *in service* to the intuition, not the other way around.

The practice that we are learning here is to make sure that intuition is always in the driver's seat, with technique being the faithful servant to your intuitive wisdom. But too often we put undue pressure on our artists' hearts, demanding that our creations make us look good to others. Or we use our creative genius to gain approval and attention, to become popular, or to make money. We rely on technique as a way to get those things instead of allowing the needs of our soul to lead the way. Instead of trusting that our authentic creative essence is enough and valuing it for how it naturally expresses itself, we let technique override our natural, creative, quirky and one-of-a-kind artistic impulses. We lose faith in our original artist's voice, and then wonder why we can't find the passion and living connection to our art.

Once we get back in alignment with ourselves and stop worrying about what other people think about our art, we begin to realize that whatever techniques we have in our creative bag of tricks can actually support our authentic creative unfolding in some incredibly fun and interesting ways.

1. What is your definition of "a good artist"?
2. What techniques do you find yourself relying on the most?
3. What scares you about the idea of letting go of some of those techniques?
4. How do you experience your tried and true techniques as a crutch? How do they get in the way and actually hinder or shut down your authentic creative expression?

5. Have you ever painted or made art without automatically falling back on your familiar techniques?
6. Are you willing to try?

31

SQUIRMY

Me: So how is your painting coming along?

Student: I'm not sure I like what I'm painting. It's making me all squirmy, and I just want to be comfortable.

Me: Well, if you wanted comfortable, coming to painting class was probably not the best idea.

Student: Did you just say that?

Me: Why wouldn't I say that? It's the truth.

Student: It's just that you don't soft-pedal or sugar-coat how hard this can be.

It's not a great sales technique, you know.

Me: How long have you been coming to this class? Like every week, religiously.

Student: Oh crap. You're right. I'm totally busted.

Me: I think you *like* how hard it is, 'cause you know the payoffs for all that inner work are pretty spectacular, but you also like to

whine about it, which is cool. Your complaints don't really bother me.

Student: I know they don't!! That's *another* thing that bugs me!

Me: Great! Now tell me what's going to happen next in your squirmy painting.

Spiritual, psychological and creative growth always entails going to our edges and beyond, which is often both scary *and* exciting. It's *always* unsettling, and even somewhat disorienting because we can't go someplace new and become someone new by doing the same old things we have always done before.

That feeling of discomfort and unease is not a problem or something to try and resolve. It's actually your secret ticket to true creative freedom. It not only leads to you breaking out of the box, but it allows the box of who you always thought you were to disappear completely. It invites you to let go of what is no longer true about who you believed you were supposed to be and instead opens you up to the process of being birthed into who you were always *meant* to be.

The choice is yours. Are you more interested in sleepwalking or waking up? Are you more devoted to comfort or aliveness? Are you more intrigued by growing or staying the same? Are you curious to break out of old patterns or more intent on settling into what is familiar and dusty and worn?

Only you can answer these questions, but it's important to remember that liberation *always* has a price. And that price is

regular doses of squirmy agitation in the service of your soul's blossoming and blooming into the creative light.

1. What is your automatic knee jerk response to the experience of discomfort in making art or in your life?
2. What kinds of things make you uncomfortable or feel unsettling when they show up in your painting?
3. Where are you feeling uncomfortable in your painting process right now?
4. How willing are you to sit with and embrace that discomfort?
5. What would happen if you went towards that discomfort by painting more of what is making you feel uneasy?

THE PROBLEM WITH PRETTY

Student: I've been thinking about coming to your retreat, but what I really *want* is to paint a pretty picture. I'm worried that I won't be able to do that.

Me: That's actually a very common concern for most of my women students.

Student: So you've heard this before.

Me: Oh yes, most definitely. I can assure you right now that you probably won't end up with a pretty painting.

Student: *Whaaaat?* Did you really just say that? What kind of sales pitch is that?

Me: It's not a sales pitch. It's a truth pitch. What I'm trying to say to you is that there's so much more to making art than just pretty. Hell, there's so much more to *you* than just pretty.

Student: Thank you so very much for pointing that out.

Me: I didn't mean just you personally. That's something that's true for all of us.

Student: But I don't *want* to paint the non-pretty parts. I just want my art to make me happy all the time.

Me: *Ah*, but here's the real truth of the matter. Pretty actually gets kind of boring after a while. But if you are brave enough to paint those things that you think of as not pretty, they often have a *tremendous* amount of energy. When you embrace and express that energy, it brings you more than "happy."

Student: What's better than happy?

Me: Well, happy is good, but it's not the only game in town. How about joy, and a powerful connection to the deepest and most essential parts of who you are? What about a huge dose of courage? Do you have the capacity to stand up for what you want and need? While we're at it, what about getting really clear about what is most important to you, or gaining a rock-solid trust in your intuitive voice? Finally, what about learning to love *all* of who you are without putting parts of you in the shame box? How does *that* sound?

Student: You make it sound pretty darn good.

Me: That's because it *is* pretty darn good, and *sometimes* you even get pretty. Pretty is like a bonus prize. Truthfully, once you get all that other stuff, pretty won't matter nearly as much anymore.

We have so many *ideas* about what will make us truly happy. Unfortunately, most of them are dead wrong. We learn that happiness is limited and narrowly proscribed, that's it's kind of precarious and easily lost, or that it's not something we can rely upon. So, we try to game the happiness system by limiting

ourselves to only painting certain things that we think will guarantee our happiness. Making a pretty painting is at the top of that list.

Our ideas of what constitutes beauty are extremely limited and often culturally conditioned. We *learn* to define certain things as beautiful. We learn to love pastels and hate fluorescent colors, or to think of circular, flowing shapes as attractive and bold and jagged lines as ugly. We're conditioned to think that old and wrinkly skin is unattractive, or that fat bodies are disgusting.

What if we lived as if everything has its own beauty, and our job is simply to open our eyes and hearts to the beauty that has always been there? How would that change our response to our creations? What if beauty is *all* there is? How would making that shift in perspective and perception free you to create whatever wants to be created?

1. What is your definition of pretty or beautiful?
2. Why is it important to you to make a pretty painting?
3. What kinds of thing do you define as ugly when you're making art? Make a list of those things.
4. Allow yourself to paint some of those things.
5. Write about what comes for you when you paint things you characterize as ugly.

NEW MEXICO SKY

Me: How's your painting going?

Student: I think it might be done, but I'm not sure.

Me: Well, if you're not sure, it's always a good idea to ask the question: "What else *could* happen in this painting right now?"

Student: I thought about painting stars in this sky, but I don't want to do it because I know it will be terribly boring.

Me: What makes you think it's going to be boring?

Student: Do you know how many stars there are in the New Mexico sky? It will take me *forever* to paint them all!

Me: *Whoa Nellie!* It sounds like you are projecting yourself way into the future with this one. You've got yourself overwhelmed with a story about how long and tedious this is going to be. The thing you are forgetting is that if you are called to paint stars, just start with one. See how that feels. You really only need to paint as many as you have the juice for.

Student: Wow! I never thought of that, although this conversation sounds vaguely familiar. I think you might have told me this before.

Me: It's highly likely. I'm not all that original. I say the same ten things to folks over, and over, and over, and over again.

Student: I only remember two of them, one of which is: "Just shut up and paint."

Me: When you get right down to it, that one is pretty much all you need.

The judging mind's job is to create a nagging sense of worry and apprehensiveness for us about the future, especially when the future is unclear and we are unsure about the outcome of our creative efforts. So, it will make up all kinds of stories about how awful and terrible, or, at least, boring, that future is guaranteed to be, in an attempt to keep us from moving *towards* that future. And when we take the risk to actually get to the supposedly scary future, we usually discover that the judging mind was absolutely and *totally* wrong. So, we need to be continually challenging and questioning those anxiety-ridden predictions, because if we believe them and act as if they're true, our creative flow will come to a screeching halt.

This is where practicing trust in the wisdom of our intuitive knowing can help us to keep moving forward and keep creating, when every fiber of our jittery and suspicious mind is screaming at us to stop. It's also helpful to remember that the fearful judging mind gets much more agitated and insistent whenever

the soul is urging us on to take a new and untried risk to become more fully ourselves.

The hardest part of this risk-taking process is right before we take the action step that will allow us to expand in often new and delightful ways. Once we commit ourselves to our creative vision by making the move, painting the star, singing the song, or writing that first sentence of our brand-new novel, the creative impulse will take over. Our flow will return and we will find ourselves immersed in the joy of creating without worrying about where our art is going, and who we will be as creators once we get there.

1. When have you allowed your fears of the future stop you from taking creative action in your painting process or your life?
2. What are some creative risks you could be taking right now in your painting process or your life?
3. Make a list of those creative desires.
4. Pick one and do it.
5. Celebrate your awesome creative courage. Now keep going.

34

WEIRD AND WACKY INTUITION

Me: So how's your painting process going?

Student: I don't know if I'm listening to my intuition, or if I'm simply weird and wacky.

Me: I think most of the time those are the same thing.

Student: I was afraid you were going to say that. So, you're saying my intuition is totally weird and wacky?

Me: I'm saying that the fact that *you* think your intuition is weird and wacky, but you're listening to it anyhow, is an *incredibly* good sign.

Student: *What*? Now I'm starting to wonder if *you're* totally weird and wacky!

Me: *That* is something you *never* have to wonder about.

We have such a hard time allowing ourselves to be exactly who we are with all of our quirks and idiosyncrasies. We worry about being seen as weird when we are truly ourselves and fear what could happen when we don't fit expectations about how we are supposed to think and feel and act. In other words all of the stuff that makes us interesting and unique and radically and unapologetically ourselves.

And when you paint from that place of true freedom and spontaneity you can be guaranteed that ALL of your wild and weirdly wonderful self will come out through your paintbrush. Those many faceted parts of you that you were told were too much or too intense or too sensitive or too bold or too different or too unacceptable will be eagerly awaiting the chance to reveal themselves on your paper or canvas in full living color. This is why the practice of radical self acceptance is such a core tenet of this intuitive painting process. With every brush stroke we are being asked to expand our creative soul container in order to hold all of who we are without judgment and to joyfully claim our unique and unrepeatable essence from a place of love and wild delight.

By making the space to allow our whole being to shine brightly without holding anything back or thinking we have to justify our very essence we regain a powerfully delicious sense of agency and sovereignty and ultimately pride in who we are. This process of sacred recognition is the ultimate act of self care and self love. And gives us the ability us to not only create with joyful abandon but to also move through the world from a grounded place of dignity, confidence and profound self-esteem.

1. What parts of you do you censor on a regular basis?
2. What are you afraid will be expressed if you allow yourself to paint without censoring anything?
3. What is the worst thing that could happen if those aspects of yourself come out and reveal themselves through your art?
4. What is the best thing that could happen?

GREEN UMBRELLAS

Me: How's your painting going?

Student: I'm feeling kind of paralyzed right now and I'm not sure what to do next.

Me: OK. Why don't you tell me a little bit more about what's going on?

Student: Well, I did what you suggested and asked the painting what it wanted me to paint.

Me: Uh-huh.

Student: And I heard a voice telling me to paint a green umbrella.

Me: OK.

Student: And then I heard another voice come in and say, "I'm not so sure about that green umbrella idea. Maybe there's something better that could come into the painting. How about a purple squirrel? Or wait... No, *not* a purple squirrel, a yellow chicken. Yeah. That would be *way* better than a green umbrella,

except you don't know *how* to paint a chicken. So, maybe a green umbrella *is* the right thing to do, or maybe a tree. Yeah, *those* are green and easy to do. If you tried a tree you wouldn't mess anything up."

So, now I'm totally confused because I don't know *what* this damn painting wants!

Me: Hmmm... So, how did it *feel* when you heard the first voice saying, "Paint the green umbrella"?

Student: It felt very calm and sure of itself.

Me: And the second voice?

Student: Well, obviously that voice is kind of all over the place and doesn't really know *what* it wants. So, I thought my intuition was simply confused.

Me: There is one thing you can count on in this work, and that is: the intuition is *never* confused. A sense of grounded assuredness is how you know it's the intuition talking to you. It's the judging mind that is always trying to keep its options open by never making any kind of a commitment to anything. It doesn't ever want to be wrong. So, it keeps jumping from possibility to possibility, like someone hopped up on way too much espresso, hoping it can land on what it considers the right choice by accident.

Student: That sounds like a pretty harrowing way to live your life.

Me: Exactly! Which is why I'm always trying to get you to listen to your intuitive voice. It might scare you because it wants you to try things that feel risky, but it will *never* confuse you by making things way more complicated than they need to be.

Student: I like the sound of that.

Me: You'll like it even more once you pick up your paintbrush and start making those green umbrellas!

One of the big problems we have with our intuition is developing confidence *in its* confidence. We have a hard time trusting in and believing that it actually knows what it knows. We don't understand how it can *possibly* be so sure of itself. It's getting information from somewhere, but the source of this certainty is often shrouded in mystery.

The intuition seems to pull ideas and conclusions and evaluations out of thin air. Which drives the left brain completely bananas. The left brain wants to have a reason for everything it does. It only makes choices and decisions that are based on some already tried-and-true guideline or past experience.

The left brain also has a tendency to get disoriented because it's operating from a place of too many choices. It wants to leave its options open, just in case something better comes along. It can't always decide which one is the right one because it bases its criteria on living up to external expectations instead of trusting in things like instinct or desire.

It's always asking questions like: "What's the thing that will guarantee I stay out of trouble with the authorities or the powers-that-be?" "What can I do that will get me lots of praise or approval?" Should I play it safe, because that's what everyone says I'm supposed to do? Should I try something new because I

don't want to be left behind? Should I fit in or stand out? How will it possibly benefit me, either socially or financially, if I take the risk of doing this thing I've never tried before?"

What it *really* wants to know is this" "If I do this thing, will I get exactly what I want? Will this action I'm contemplating achieve a guaranteed outcome?" It wants utter assurance of success for every step it takes, and the promise of complete certainty.

Intuition's criteria for any undertaking are quite different from the ego's, and are based on soul values. The questions it's most interested in asking and answering are related to the inner realms of our being. Questions like: "Does this activity make me feel more alive and connected to myself? Does it feed my essence? Does it open my heart? Does it support my ability to be courageous? Does this action allow me to express some deeper hunger or desire?"

Above all, it doesn't ask for certainty or definitive answers to these questions. It only asks for the opportunity to engage with the sheer vitality of your authentic aliveness.

Your intuition is an ever-present gateway to a non-linear, non-logical, and non-rational intelligence. It *is* an incredibly powerful type of perception and knowing. It's just a different form of comprehension from your cognitive, head-based way of perceiving, because it is rooted in the deepest recesses of your heart and bones and guts. But it's definitely one that we *can* trust, once we learn how to listen to it.

The intuition actually does know the exact best thing for our soul's growth.

That IS something that is guaranteed.

So, our job is to practice hearing it and following its directives, and then learning for ourselves how powerful, satisfying, and magical living our lives from that deep inner knowing can be.

1. What are the ways your intuition communicates with you? Does it speak to you in language, or through your body sensations or via flashes of visual insight?
2. What is it that you don't trust about your intuition?
3. What did you learn about intuition from your family or culture when you were growing up?
4. What is your intuition saying to you right now?
5. What would happen if you really listened to it and did what it was telling you? Right now?
6. Are you willing to find out?

A BRAND-NEW COMPASS

Me: So, what's happening in your painting?

Student: I think I want to redo this face on the woman I painted.

Me: And why would you want to do that?

Student: I just don't like it.

Me: What don't you like about it?

Student: Well, the lips are too big and the nose is crooked.

Me: Oftentimes when we say we don't like something, it's because we don't like the way it's making us feel. So, is there some feeling that you want to get rid of that is being touched on when you see the lips and nose of this face?

Student: Oh crap. *How* did you know that? Is this a trick question?

Me: You should know by now that they're *all* trick questions. So, what's the feeling you don't want to feel?

Student: Well, when I really think about it, I realized that the nose and lips thing is just a diversion. What's *really* freaking me out are the eyes, because they are so incredibly sad. That's certainly *not* what I intended. I think they look that way because I don't have the technique to make them turn out the way I want. It's simply a mistake and I want to fix it.

Me: I can't tell you how many times I've heard *that* story from folks. This type of painting process is about learning to trust in your body and your spontaneous expression, which is how your intuition comes in under the radar of your attempts to control things. So, from that vantage point there *are* no mistakes. The painting is simply a mirror for where you are right now, and you're obviously struggling with what you're seeing in your painting mirror.

Student: I don't think I like *you* very much right now either.

Me: That's another thing I hear from folks on a fairly regular basis. So, if you were going to allow yourself to go *towards* that feeling of sadness instead of trying to get rid of it, what else could happen in the painting?

Student: Well, I *could* paint some tears, but I don't *want* to paint tears. Tears are so trite and predictable.

Me: That certainly sounds like a judgment. Don't forget, what you want and like doesn't matter very much around here. The only *real* question is this: Is there energy for the tears?

Student: Yes. Yes. There's energy for the tears. Dammit.

Me: OK. So, it looks like you'll be painting some tears.

I go away for a while to work with another student, and then I come back.

Me: So how are you doing with your painting now?

Student: As you well know, I resisted mightily at first. But then, as soon as I began to paint the tears, I couldn't *stop* painting the tears. They started coming out of everywhere faster than I could move my brush. First, they came gushing out of her eyes, but then they started to come out of her ears. Finally, they filled her mouth and came pouring out of there, too.

Me: And how did you feel as you were painting those multitudes of tears?

Student: Well, the weird thing is that I wasn't sad at all in the way I feared. I thought I would fall into a place of depression and darkness if I went towards the sad imagery, but painting those tears made me feel incredibly alive. It was like I found myself standing on these amazing shifting sands of emotion where happiness and sadness were happening at the same time, and were all the same thing.

Me: It sounds almost psychedelic!

Student: Yeah, I did have a moment of wondering if you had slipped some magic mushrooms or something into my tea. It really was that intense.

Me: You don't need magic mushrooms when you're willing to allow the painting to lead the way.

Student: Yeah, I see that now. I'm still a little discombobulated, but in a good way. I keep thinking that I have to control what's happening in order to be happy, but I discovered that listening to my intuition took me to a place of profound joy that is so much better than that experience of being in control. It's like I stumbled upon a whole new compass for my life.

Me: I'm speechless, and so thrilled you found your way here. You do realize that helping you get to this place of freedom and letting go of control is the main reason why I badger you so much.

Student: I know. You're evil, but it really, really helps.

One of the functions of the intuition is to guide us towards inner experiences that allow us to become more whole and healed. Which means we need to allow ourselves to feel everything as it arises. Opening up to our emotions can be scary because we don't know where they're going to take us, but one thing we can be sure of is that they will take us to the core of what's most real and alive for us in any given moment.

We forget that our emotions are a fluid and ever-changing part of our being, and, like water, they need to continually be in motion. They are actually guaranteed to change, because that's what they do. They will only keep flowing, however, if we allow them to be felt and fully expressed.

I often hear people talk about wanting to get rid of their emotions, especially the painful ones, as if they are some bad or toxic substance. But our emotions are an essential part of who we are, and when they arise we need to make space for them and be present to them as fully as possible, with as much acceptance and compassion as we can muster. Thinking we can banish them is based on the belief that we can reject a huge part of what makes us human without any negative consequences.

Denying or repressing our emotions is something we learned as children to keep us safe at a point in our lives when it was dangerous to feel. We need to honor that process of repression as something that was necessary and valid at the time, but as adults we have agency and power and the ability to care for and protect ourselves. This means we can also protect that vulnerable inner child, and make space for many of those long-buried feelings to come to the surface to be healed and expressed. Trusting in our feelings allows us to trust more deeply in ourselves, to trust more deeply in our own creative wisdom, and ultimately, to trust more deeply in the flow of life itself.

1. What emotions are the most uncomfortable for you to feel?
2. What scares you about intense emotion?
3. What did you learn about feeling and expressing emotion in your family when you were growing up?
4. What are some of the ways that you deny, distract yourself from or repress your emotions?
5. What emotions are you feeling right now?
6. Paint from that place.

MIRACLE HEALING

Student: I think I need to stop painting for now. My eyes are *really* burning and hurting me.

Me: *Awwww*. That's too bad. Sorry to hear you're in pain, but you know, you could try painting with your eyes closed. That would be a whole other level in the practice of trusting the brush.

Student: Could I start a new painting, or do I have to continue on the one I've already been working on?

Me: Definitely stay with the one you are already engaged with.

Student: *Harrumph*. I knew you were going to say something like that. That's going to really challenge me around letting go and surrendering my attachment to how it looks, 'cause I really *like* this painting.

Me: I know, but that's why you're here—because some part of you really does want that challenge!

Student: Oh. Wait a minute. All of a sudden my eyes feel just fine. In fact they feel *great!* I think I've been healed!

Me: (Laughing) Why am I not surprised? The power of the healing brush strikes again!

Whenever we begin the journey of trusting in our intuitive knowing and creative wisdom our resistance can show up in the most interesting ways. One of the most popular resistance tactics is to use bodily distress or uncomfortable sensations to stop us from moving forward, or to at least slow us down.

We can get so very *convinced* that our tiredness is real and we just *have* to lie down, or that the pounding headache we feel is a sign that something is terribly wrong and it's time to stop what we're doing immediately. This is one time when you *can't* trust your body, because those signs of distress often mean it's been hijacked by your wily, fearful, judging mind.

The intuitive painting process not only challenges us to take risks and try new things, but by doing so it also helps us break free of old patterns that have been keeping us creatively stuck and shut down. Being liberated from those patterns also releases a lot of energy, both emotionally and on the physical level. We simply begin to feel an increased sense of vitality, and have to learn how to expand our energetic capacity to embrace that new-found aliveness.

So, the next time you're painting and you feel a little queasy, or are compelled to take a nap, stop for a moment and ask yourself this question: "What might I be resisting in my painting process because I'm afraid that I'll do it wrong or make a mistake, or I'm convinced that I'm just not good enough or talented enough to

do what my intuition is asking me to do?" Then simply do that thing you're avoiding, and watch in amazement as your body perks up, your creativity blossoms, and your spirit soars. At that point a snooze will be the *furthest* thing from your mind.

1. How do you notice resistance showing up in your body when you're painting?
2. What comes up for you around this idea that your resistance can express itself through tiredness or pain in your body?
3. Pay attention to when you get tired while you're painting and begin to notice how your tiredness is possibly related to the fear of taking risks.
4. Paint the risky thing. See what happens.
5. When you begin to see that connection between resistance and risk, take a few moments to journal about how that impacts your painting process.

BE HERE NEXT

Me: How's your painting going tonight?

Student: I think it's OK. I'm painting these brown squiggles in the heart of this figure, and I'm feeling pretty calm and content.

Me: That's great!

Student: But it feels kind of weird. I'm not used to calm and content.

Me: Hmmm...

Student: So I'm wondering what's next.

Me: It sounds like it's kind of hard to just be here where you are.

Student: Yeah, I mean... how long can this last? I don't know if it's a good idea for me to let myself just hang out here. Shouldn't I be preparing for when things get hard, and bad, and messed-up?

Me: And how do you propose to do that?

Student: I don't know! That's part of the problem, but I'm pretty sure I should be doing *something*. Anything is better than this!

Me: Anything is better than feeling calm and content?

Student: Well, no, but I'm not *feeling* calm and content anymore. Now I'm all agitated and worried.

Me: Funny how that happened. What if you came back to simply painting what was making you happy?

Student: How is *that* going to help me when the Apocalypse comes?

Me: Wow! You've gone from calm to Apocalypse in under a minute! I must say, I'm rather impressed.

Student: Yeah, I'm kind of impressed, too.

Me: So, do you have a sense about how you got here?

Student: Well, you always talk about how this process is about staying in the present moment, but I think I catapulted myself into an imaginary future, and it was a *scary* imaginary future.

Me: Yes, you forgot for a moment that this is the Be Here Now class, not the Be Here Next workshop.

Student: Do you actually *have* a Be Here Next workshop?? I might *really* be interested in that!

Me: Uh... No. Let's just see if we can get you back to those happy squiggles.

This intuitive painting process invites us again and again and again into a sense of fully embodied presence, which can only happen in the here-and-now present moment. And for those of us who are used to living primarily in our heads, being that deeply connected to our bodily experience can be terribly uncomfortable. Feeling without thinking, or *not* creating a story about what we're feeling, can just be plain weird. It's also sometimes hard to *value* our feelings and sensations if we don't understand where they come from, or can't find a good reason for why we're having them.

When we're struggling to figure out what's going on inside of us with our thinking function, or are unable to make some kind of logical, rational sense of what we're feeling, the mind can become so anxious about the experience of simply being *here* that it starts to hijack the incredible power of our imagination. And it does this by making up scary stories that compel us to abandon that sweet space of presence and get drawn into future-tripping, catastrophizing, or ruminating on the past.

When we lose connection to our creative source and succumb to our anxiety-ridden thoughts, it can be very helpful to slow everything way down. All we really need to do when that happens is to pick up a brush, take a moment to breathe, feel our feet on the ground, choose a color, and make one mark on the page in front of us. Then another, and another, simply calling ourselves back to the practice of being here now with the brush, the color, and the breath. Through painting in this moment to moment way we are honoring the invitation to

inhabit our bodies more fully with each brushstroke, each
spontaneous impulse, and each creative desire.

Being present to ourselves while we make art gives our body and
heart the message that it's safe to create. It's safe to feel. It's safe
to be ourselves. It's safe to be here as a creative being on this
gorgeous blue-and-green planet, and to express ourselves with
playful abandon in as many ways as we possibly can.

1. What comes up for you around this invitation to be
 more present to yourself?
2. Take a moment to write about your felt experience on
 the physical, emotional and energy levels of being alive
 right now.
3. Allow yourself to paint from that place of simply being
 where you are in this moment.

THROWBACK PAINTING

Me: So how's your painting going?

Student: I'm having so much fun with this painting. Every brush stroke brings me such joy, but when I stand back and look at it I simply *hate* it!!

Me: So, don't look at it.

Student: What do you *mean* don't look at it? How can I not look at it?

Me: Just stay up close to the canvas and keep your attention on the good feelings.

Student: (Grins and rolls eyes)

Me: Plus, focusing on what is wrong with your art is *sooo* Twentieth Century!

Valuing what we think over our direct experience of feeling and simply being IN our experience is another way that the left brain/ judging mind hijacks our life force energy. Our thoughts about what is happening in our paintings or our life keep us separated from our palpable and somatic truth.

Very often those two things are radically different. I can't tell you how many times I have had conversations with my students like the one above where their thoughts about their painting or their process are very negative and even punitive, but what they are feeling is happiness or excitement or even joy. Our minds want us to conform to a societally approved manner of expressing ourselves and that desire to play by the rules shows up in a big way in our art. This is where we get all caught up in questioning whether or not our paintings are pretty or meaningful or sellable. And if we paint something we think is ugly or meaningless but we're actually enjoying the process of creation our inner critic gets very noisy and tries to distract us from our pleasure and what is a more grounded relationship to our actual lived reality.

This is where I remind my students to be highly suspicious of their opinions about their art and art making. And simply practice being present to what is truly happening in their body, heart and soul as it shows up in their painting process.

1. Write about some ways that you recognize yourself in this scenario of feeling one thing but thinking another in relationship to your painting process.

2. What do you notice when you try to consciously practice simply enjoying the experience of painting without worrying about what it looks like?

3. Write down any inner critic messages that come up as you engage with this painting pleasure practice.

4. Now practice shifting your attention back to what feels good as you paint. Keep playing with this dance between these two parts of yourself so that you can increase your awareness around this internal process.

5. How willing are you to commit to honoring your own creative pleasure?

JUST DO IT!

Student: *Whaaaa...* I know that a big part of this intuitive painting practice is going through a completion process around my painting before I start another one. And I'm pretty sure I'm not done. But completing it means I have to look at it again and probably even paint on it some more and I don't *want* to come back to my painting from last week. I hate it!

Me: That's OK.

Student: *Whaaaat?* Are you saying that I don't have to continue on this painting even though it's not finished? I've *never* heard you say *that*!

Me: Oh no, no. What I meant is you don't have to *want* to come back to this painting. You just have to do it whether you like it or not.

Student: *Harrumph.* I figured it was something like that. You know, you never let me get away with anything in this class. You're always keeping my feet to the creative fire.

Me: And you wouldn't have it any other way.

This intuitive painting process is above all else a creative, intuitive and spiritual act of devotion. It requires a profound level of commitment to be effective. And like any serious practice there are principles that you need to follow in order to get the most out of it. One of the core intuitive painting concepts is related to the importance of completion. Which is a big deal for most creatives. Whenever I tell new students about this criteria I often get a horrified look followed by a guilty confession about how many incomplete paintings they have strewn around their home or studio. Most painters don't know what it means to actually finish something because they don't know how to let the painting talk to them and lead the way.

In this approach to painting you are asked to honor and respect each of your paintings by staying with it until it lets you know it's done. That is one of the primary practices. And the thing about practices is that they are designed to bring us right up the edges of our resistance. Which is why it's so important to stay true to the practices no matter what we think or feel because some part of us is always going to try and dilute the power of the practice by convincing us that we don't need to follow through on our initial commitment.

Paying homage to a practice often looks like doing something that we don't want to do in the service of developing some aspect of ourselves. In this case, we are learning how to develop a much more robust and trusting relationship with our intuition as it is expressed through the process of painting. And that might look like staying with a painting through those gnarly times when we

hate it or when we are feeling tremendously uncomfortable because of where it is trying to take us.

1. Name some of your familiar patterns around this issue of completion and your art.
2. How do you feel about these patterns?
3. How would you like them to be different?
4. What would it look like for you to truly listen to your painting and allow it to tell you when it's done?
5. What comes up for you when you are asked to make a commitment to any kind of creative, spiritual or healing practice?
6. What are some creative, spiritual or healing practices you would like to bring into your life?

STAYING ALIVE

Student: I think I'm really getting it. It doesn't matter if I like what shows up in my painting or if I understand it. If I have energy for it, that's enough.

Me: Yes, the only thing that matters here in this process is life and being alive.

Student: But it's just so easy to be dead and numb and shut down.

Me: I know. Being alive means being unpredictable, uncontrollable, unbridled, unbroken. We get all kinds of messages from the outer world about how dangerous it is to be *that* alive.

Student: But I *want* to be that alive.

Me: You already are sweet painter. You already are.

The core of this intuitive painting practice is an ongoing invitation to become fully alive through the process of radical self-acceptance. This means feeling everything, seeing everything, accepting everything, respecting everything, opening your heart to everything that lives inside of you. It doesn't matter how challenging or difficult or painful what's within us is, how tender or vulnerable or sensitive. When we express everything about who we are, courageously and without restraint, holding nothing back, we are truly awake.

It's a practice of creative liberation, an ongoing invitation to becoming a freedom-fighting revolutionary who challenges the status quo, saying *no more* to any form of creative oppression. It means standing up to the art police, both inner and outer, and becoming a willing rule-breaker in the service of love and integrity, justice, and courageous authenticity. It means never forgetting that we can't ever be fully free if we are rejecting aspects of our essential being, disallowing them from entering our conscious awareness and keeping them out of our own hearts.

It's a practice of claiming the exuberant fullness of our creative joy and the lavish generosity of our creative brilliance and innate artistic genius, by allowing our creativity to be seen and heard and celebrated in loving community as holy and sacred. It's a practice of radical truth-telling and ruthless honesty, an opportunity to bring into the light of day all those places in our soul and psyche that we hide out of fear and shame, and bringing healing to those wounded places through the process of witnessing them in the spirit of tender compassion.

Finally, it's a practice of devoting ourselves to honoring the divinity that lives inside of us, expressed as the wisdom of the life force, and surrendering to how it flows through us like a raging, rushing river of boundless love, unfailing healing, fathomless mystery, inexhaustible creativity, and everlasting magic.

1. What does radical self acceptance mean to you?
2. What types of inner oppression do you need to overthrow in order to become more creatively free?
3. Where could you be more creatively courageous in your painting practice and your life?
4. What aspects of your creative being need to be held with more compassion by you?
5. How do you experience your inner wisdom and divine, creative nature when you paint?

WHERE IT ALL BEGAN

EVERYTHING I KNOW ABOUT TRANSFORMATION I LEARNED BY
MAKING ART.

"If I keep painting in this way I'm not going to have to change my life?? Am I?"

— Anonymous Wild Heart Painting student

When I was a very young woman, many many moons ago, I wasn't very happy with my life. I didn't have a very clear sense about who I was and I didn't know what I wanted. I only knew that what I did have wasn't working and I needed things to change.

So I moved from the urban midwestern part of the USA out to wild and wacky California which totally changed my life. I was so enamored with the joys of transformation that I even started working in the transformation biz as a healer and guide.

I believed in the power of change. I knew firsthand that it was possible to reconfigure a life.

And it did work. But only up to a point. A lot of what I changed were the externals. I had a whole new circle of friends and was

exposed to new and different ways of thinking, eating, dressing playing, working and living.

And for a while those external changes were enough. They satisfied me and allowed me to feel more authentic and alive.

It took me a while to notice that certain patterns and attitudes that I thought I had left behind were still very much intact. In fact, some of my inner blueprints hadn't really changed at all.

I was still operating out of the belief that the only way I could get love and attention was by being what other people wanted me to be. I was still working too hard to get approval. I was still sacrificing my authentic needs for rest on the altar of patriarchal productivity.

This was incredibly frustrating. Because it's not like I didn't try to change. I made plans and set goals and tried to shift things through harnessing the power of intention. I tried to gain insight and do my psychological work. But some mysterious force continued to thwart my desires for fundamental change.

It's like I packed my bags and said my goodbyes, got my passport and bought my ticket. And then I got on the train all full of the prospect of a new adventure and possibility and then when the train doors slid open, I found myself standing on my own doorstep again.

Which of course completely sucked.

One of the things that wasn't working about how I was approaching this process of transformation was how much effort I was putting into it. I was trying way too hard. I was also wanting to change out of a place of feeling that there was something wrong with where I was to begin with. I was trying to

get rid of what I thought was the bad behavior. I was approaching this process from a place of judgment and shame.

And wondering why it wasn't working.

At some point along the way I got introduced to the intuitive painting process. But my purpose for doing this wasn't because I trying to change anything. I just needed to do something that was nurturing for me.

One of the most amazing things I learned through this process was the healing power of accepting whatever showed up. And learning to not see what I painted as good or bad. In fact, I got really good at just being curious about things I thought were messy or ugly or just plain weird.

At the time when I was first discovering this process I was also in graduate school, getting a masters degree in clinical psychology, so the painting was a much needed respite from papers and deadlines, evaluations and the stress of having to accomplish something. The painting also took me outside of my head. I wasn't thinking while I was painting. I was just lost in a world of color and imagery and the sensuality of brush on paper.

At first it was just recreation, a way to keep myself somewhat sane while I made my way through graduate school. But as time went on I started having some pretty wild experiences with the creative process. I would paint, some times for hours and days on end and I would leave the studio and be in a distinctly altered state.

Colors would be more vibrant and intense, things around me were infused with a sparkling, pulsating energy. The world and myself in it just seemed more vital.

My life outside of the studio DID start to change. As I listened to and trusted my intuition through the process of painting I started listening to and trusting myself in other ways. I seemed to know more clearly how to proceed with my life. As I took more risks in my painting I was willing to take more risks in places outside of the art studio.

For example, I was involved with a man who was unable to make a commitment to me and all of a sudden I had the guts to leave the relationship. I had completed my graduate school program and was expected to embark on a grueling internship path that would lead to professional licensure, but I no longer had the heart for it, so I walked away.

I had faced the void so very many times in my painting, not knowing where the next stroke would lead me, but always trusting that something would happen if I just listened for the next instruction.

And here I was, living in the same way that I had been painting. It was scary and intense, but also so very alive. And it did work. Instead of getting a license to practice psychotherapy I started my Creative Juices Arts business where I began helping people to open up and live from their own creative source. I was alone for a while, but then I met the man who is now my husband (and of course, an artist), and it is 25 years later and we are still incredibly happy together.

As I trusted more and more in my own creative energy, the energy to actually create my own life, things just fell into place. My journey during this period was not without fear or sadness or stress, but underneath whatever sense of difficulty I might be experiencing was always a layer of trust. There was something that I was tapped into that was guiding me and it was the same energy that guided me while I was painting. I had learned so

much from standing in front of that easel about being present and not judging. About following my own individual energy and about following my heart. I learned that going into what seemed like dark places always led to some sort of transformation and I learned about the value of surrender to an energy greater than myself.

It was a very powerful yet humbling period in my life and it really changed everything.

And I have the utmost confidence that this intuitive painting process can also transform *your* life in the most magical ways. All you need to do is pick up your brush and keep painting from the truth of your wise and wild heart.

ALWAYS LOOK FOR THE HELPERS

So the story begins with my Muse getting fascinated by this whole idea of turning conversations I have had with my students over the years into actual teaching tales. She's the one who decided that this project would be a great deal of FUN... and when she invites me to do anything, I have learned to listen. So I always need to thank her first!

But just as importantly, there *would be* no story without my wild heart creative community and my courageous students for their openness to exploring their creativity, their inner lives, and their blocks to healing their souls and psyches through art. Without their willingness *to do* this sacred work of reclaiming their intuitive and creative selves, I would have no tales to tell.

Initially, I posted some of these stories on FaceBook and *got such* a wildly enthusiastic response to them—*plus* requests from my peeps, there, that they be made into a book—that this gave me the confidence to actually begin to make that happen.

A story needs a magical helper to make it truly sing, and this book got a sparkling shine job from Claudia Love Maier, editor

par excellence. I am eternally grateful for her deft yet gentle editing touch and her ability to turn my writing into a river of inspiration that flows freely without being log-jammed by extraneous verbiage and too many commas!!

There is a point in the journey, where you enter a totally alien landscape and need an experienced advisor to guide you through unfamiliar and often unnerving terrain. Naomi Rose provided the expert guidance that allowed me to navigate the self-publishing world with ease and grace, and go through the transformation from being a writer into becoming an author.

And finally, the story begins and ends and keeps on going because of my husband and life partner, Tim Lajoie. He is my biggest cheerleader, who believes in me more than I can sometimes believe in myself. He is my rock, who always has my back no matter what. He is my playmate and my creative compadre in life and art. In addition, he is both a tech wizard and a craftsperson who can build or make *anything,* whether it's a website, an easel, an art studio, or a book layout. My gratitude for his partnership, love, and devotion is as wide and expansive as the endless New Mexico sky. Without him, I would not be where I am today.

MY CREATIVE MANIFESTO

Chris Zydel

Chris Zydel, M.A. also known as Wild Heart Queen, is head creative goddess at **Creative Juices Arts.** She has over 40 years of experience as an expressive arts facilitator and a compassionate creativity guide, as well as an unshakeable faith in the power of creativity to heal hearts and change lives. She knows deep in her bones that everyone is wonderfully and gloriously creative, and she is on a relentlessly love-soaked mission to prove that to the world. She performs this magic by writing her books and

providing nurturing and joy-filled creative healing circles that overflow with kindness, encouragement, permission, and trust in the sacred energy of play and creativity that lives inside of us all.

She lives with her adorable and supportive artist-husband in a wildly colorful home in the San Francisco Bay Area. Her muses are love, mystery, and magic... color and music... luminous language... and wild, wiggly words.

She cannot get enough of *anything* that has to do with art, and is constantly painting, writing, taking photos, making jewelry, or designing her many classes, workshops, retreats, and training programs.

Devotion to the process of creation is her passion, her primary method for physical and emotional healing, her medicine, her spiritual practice, and her entry into deep soul work. When she's not making art, she spends as much time as possible outside in the natural world, where she has an ongoing love affair with the mountains, the forests, the ocean, and the red rock deserts—and, as always, a deep and abiding connection with spirit and the sacred heart.

For more info about the Wild Heart Expressive Arts Intuitive Painting process, visit Chris's website at:

www.creativejuicesarts.com

Or follow her on:

facebook.com/chris.zydel
instagram.com/wildheartqueen
linkedin.com/in/chris-zydel-171849

CPSIA information can be obtained
at www.ICGtesting.com
Printed in the USA
LVHW051121030322
712397LV00011B/956